BLONDIE

UNSEEN 1976-1980 ROBERTA BAYLEY

Plexus, London

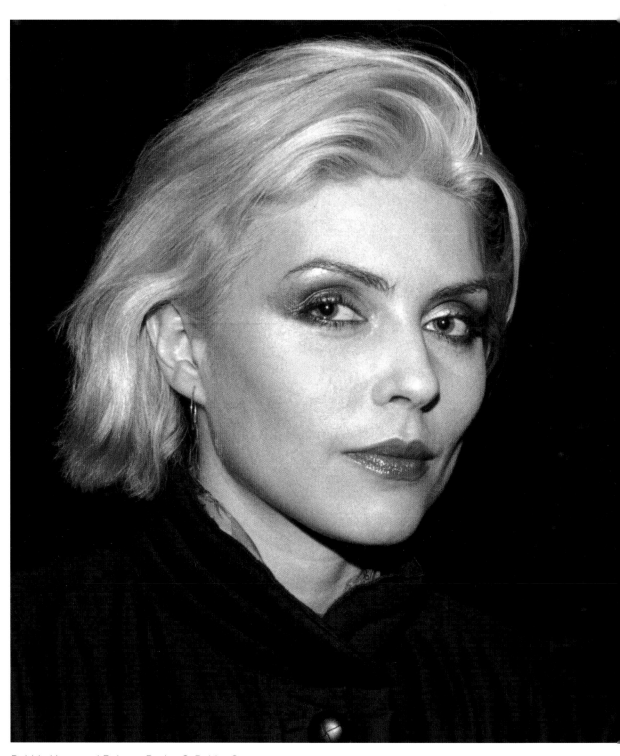

Debbie Harry and Roberta Bayley © Bobby Grossman

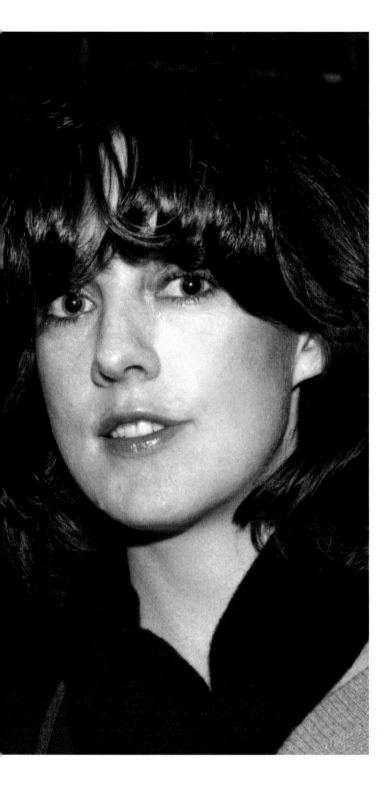

Everything has changed
The people. The air
The roller coaster isn't THERE.
Some of us remain.
I only missed them days
right after 9/11. Missed 'em
To tears. Just wanted The
'70's back again. wanted
innocence, wanted blind
sided desperate love, and
To be noticed.
 Now That I've been noticed.
I want otherThings.
 About the photos too
many dead but what away
to go. I guess yen just had
to be There. Roberta was.

— D. Harry

BLONDIE'S NEW YORK ROOTS

In April of 1974, I arrived in New York, not knowing a single soul. I had a list of 'friends of friends' upon whom to call, and that was it. I called a woman on my list named Judy Markham, and she invited me to stay at her loft on Warren Street. The next day, I located an old friend named John Newman from San Francisco, who was living in Brooklyn and had a spare room. I was temporarily set up. Another person on my 'list' was David Nofsinger. He showed me around the city a little, and asked me what I wanted to do in New York. I told him I wanted to see the New York Dolls, who were currently playing shows in the city. I'd missed them when they played in London and San Francisco, and they were the only band I was curious about. It turned out that Nofsinger had been the Dolls' soundman on their European tour, and they were playing at a club downstairs from his loft on East 4th Street, called the Club 82. He arranged to have a party at his loft after the show.

The Club 82, at 82 East 4th Street, was originally owned by one of Lucky Luciano's early cohorts, Vito Genovese. Though heroin was at the centre of the Genovese empire, Vito also owned several nightclubs, usually purchased in other people's names. The 82 Club (as it was then called) featured drag queens, which was considered risqué at the time. At its height, the 82 drew celebrities such as Elizabeth Taylor and Montgomery Clift. By the seventies it was a discotheque, and was put on the map when David Bowie visited one night. The doorperson was a butch lesbian named Tommy, who let people she liked in for free.

The New York Dolls had released their second album and were doing a series of shows in different New York clubs, their 'Easter Tour'. The mere existence of the Dolls, even though some thought they were past their peak, was so much more glamorous to me than anything I'd experienced in London. They carried an excitement around them that was like a floating party.

A band called the Miamis opened for the Dolls at the 82. They wore suits and bright red lipstick. Their music was catchy and energetic, but I was a little confused by their image. When the Dolls made their entrance, I was somewhat taken aback. David Johansen wore a strapless sheath dress, a bouffant wig and high heel pumps, with a leather motorcycle jacket thrown over his shoulders. The other Dolls also wore various forms of female clothing. Never having seen the band before, I wasn't in on the joke, and thought this was their 'normal' look. In fact, as an *homage* to the history of the 82 Club, they had decided (all but Jerry Nolan, who wasn't having any of it) to appear in actual drag!

After the show, everyone from the Miamis and the Dolls (except Johnny Thunders) and their friends came to the party. It was quite a scene, lots of crazy-looking people in makeup and wild clothing, not like anything I'd experienced in London. The Dolls had changed out of their drag attire – I remember David Johansen was wearing a cut-off sweatshirt!

Everyone was friendly and ready to give me an introduction to the city. I went to a party at the Miamis' apartment, and, later, Jimmy Miami took me to see the Dolls – who were opening for Suzi Quatro at the Bottom Line – and also Patti Smith and

Television at Max's Kansas City. That was something different. While Patti had been playing around New York for awhile, I had not heard anything about her. I liked Television a lot, they were both electrifying and funny, but Patti was a complete revelation to me. I had never seen a performer like her, so very mesmerising and hypnotic.

The as yet unnamed punk scene was just beginning to coalesce. In *Making Tracks: The Rise of Blondie*, Debbie Harry called 1974 the 'non-period of punk', but for me, who had been living in London for two years and had experienced a *real* non-period, it was an exciting time. The New York bands were beginning to form, influenced by the Dolls' energetic stage show and local popularity, some by art and poetry, the Warhol aesthetic, or by New York City itself. Even though there was supposedly 'nothing happening', with the city bankrupt and on the skids, there was still a palpable feeling in the air that spring and summer of *possibility*.

One day that summer, I was walking with Dale Powers of the Miamis on East 10th Street, and ran into Richard Hell. I had read Patti Smith's article in *Hit Parader* about Television, and I was intrigued by Richard, who had an unusual appearance mixed with Southern charm. Later, I went to a party at Terry Ork's loft and Richard was there, but back then (as now) I wasn't too fond of parties, so I bid him *adieu*, quoting a line from his song, 'Fuck Rock 'N' Roll', saying I'd rather 'read a book'. Later that summer, I ran into Richard at Club 82. Nofsinger was out of town, and I was staying at his loft upstairs. Richard and I hooked up that night, but I was leaving for California two days later. I managed to find him at his manager's loft and say goodbye over the phone, but that was that. Or so I thought.

Richard and I started a correspondence, and later he asked me to come back to New York and move in with him. I arrived just after Christmas. Television were playing Sunday nights at CBGB's, and their manager, Terry Ork, asked if I would take the admission money at the door. This turned out to be a pleasant job, because, instead of just hanging around waiting for the band to play, I had something to do. I met everybody who came to check Television out, and, at that time, they were the band everyone wanted to see. Most of the audience was made up of musicians from other bands, and they all got in for free. Television were interesting, with unusual, original material, and Richard was pretty animated onstage – jumping around, much to Tom Verlaine's disapproval.

I met Deborah Harry and Chris Stein of Blondie at CBGB's. Blondie were actually the first band after Television to play there, but that was a little before my time. Debbie always had a great 'look'. In fact, it seemed to me she never repeated an outfit. She didn't just show up anywhere in jeans and a T-shirt – unless they were *pink* jeans, a cool T-shirt and a pink beret. Part of the fun of going out was to create a look. Even with little or no money this could be easily achieved, combining thrift shop chic with the bargains on 14th Street, and a little street scavenging for good measure. Debbie had been part of the

glitter scene, which relied on vintage discoveries for its glamour. As glitter faded, so did satin and lace. Something new had to take its place, and Richard Hell was undoubtedly one of the masters of this new style. He turned the necessity of holding his clothes together with safety pins and staples into a look. No one could afford logo T-shirts of their band – why not just write your slogan on with a magic marker?

Debbie had had a band called the Stillettoes, who played at the Boburn Tavern on 28th Street. Chris saw Debbie at the Boburn and soon left his band, the Magic Tramps, to join the Stillettoes. There were three girl singers, Debbie, Elda Gentile and Rosie Ross; Fred Smith was on bass, and Billy O'Connor played drums. Tommy Ramone invited the band to rehearse at Performance Studios on 23rd Street, where the Ramones rehearsed. Elda was dating Richard Hell, who invited the band to play at CBGB's. It was a pretty small scene.

This was the period when what would become Blondie was in a constant state of transition. The Stilettoes broke up, then Debbie and Chris's band became Angel and the Snake for two shows, played a few gigs with no name, and then morphed into Blondie (because they briefly had two blonde back-up singers). Later, they played uptown at a club called Brandy's, with Tish and Snooky Bellomo (who would later have a boutique called Manic Panic on St Mark's Place, and start a revolution in hair colour with their product line). This version of the group was called Blondie and the Banzai Babies, and played together for over a year. Around this time, Billy O'Connor left to pursue a non-musical career. The band auditioned dozens of drummers, the last of whom was Clem Burke – who was not only an excellent drummer, with great musical taste and a cool fashion sense, but also had the youthful enthusiasm the band desperately needed.

Among the transitional shows around that time were the New York Dolls' performances at the Hippodrome, uptown. Malcolm McLaren, their manager *du jour*, had the Dolls outfitted in red patent leather, and a huge banner of the hammer and sickle as a backdrop. The shows were tremendous, though the image confused some of the audience and most of the press. Opening for the Dolls were Television (with Richard still on bass), who had a very different look and sound. One afternoon, en route to a Sunday matinee by the Dolls, Debbie stopped in her Camaro to give Richard and me a ride uptown. After the show, Johnny Thunders and his girlfriend Julie gave us a ride home. Like I say, it was a very small scene.

Malcolm took a lot of the stylistic and musical ideas of Richard Hell and Television back to London, where he would begin to develop the British version of punk. A few weeks later Richard left Television, and Johnny Thunders and Jerry Nolan left the Dolls. David Johansen met with Richard at Ashley's, to talk to him about joining the remaining Dolls, and, later, Johnny and Jerry approached Richard about joining them. Having the same chemical proclivities, and not wanting to join an established band that appeared to be on its last legs, Richard formed the Heartbreakers with Johnny and Jerry.

Blondie were doing gigs at White's Pub, where Debbie was also a barmaid. This was where I first saw them play live. Here Debbie also met Anya Phillips, briefly a fellow barmaid and general all-round girl on the scene. Anya would become a close friend of both Debbie and myself. She would design some of Debbie's most memorable outfits, including the pink dress she wore on the cover of *Plastic Letters*. Later on, she also became the manager of James Chance, and James White and the Blacks.

During Blondie's first CBGB's show with this line-up, bass player Fred Smith abruptly broke the news that he was leaving the band to replace Richard Hell in Television. Television were the band everyone thought were going to break out and be successful. It was yet another setback, and, at the end of 1974, things didn't look too promising for Blondie.

However, Clem Burke would not be deterred. He brought in his friend Gary Valentine from Bayonne, on bass, and encouraged the band to keep working. They played CBGB's every week for seven months, writing and rehearsing whenever they could. Jimmy Destri, a young keyboard player who had played briefly with a band called Milk 'n' Cookies, soon filled out the line-up.

The energy was building, and things were really starting to come together. In August of 1975, the band moved to a loft on the Bowery, just down the road from CBGB's. Now they had a Blondie headquarters where they could live, rehearse, write and take bookings for the band. An added bonus was the presence of a neighbour, designer Stephen Sprouse, who would be a great influence on Debbie's visual image. Sprouse had worked with Halston in the early seventies, but had a decidedly modern, downtown sensibility. He and Debbie would become close friends.

Clem took a few weeks off to visit his girlfriend, Diane Harvey, in London. Always a devoted anglophile, he returned with the first LP by Dr. Feelgood, an energetic, stripped-down foursome who had just gone to number one on the British charts. Maybe it *was* possible for some of this new music to be commercially successful. With renewed enthusiasm, Blondie began to practice every afternoon and evening.

Richard Hell and I broke up around this time, but we remained friends. I moved into an apartment on St Mark's Place and bought a Pentax Spotmatic camera. The Heartbreakers had a gig coming up, and Richard asked me to take their picture for a poster. I'd had my camera for about a month. The session resulted in the famous 'blood' pictures, later used on the cover of *Please Kill Me*, Legs McNeil and Gillian McCain's history of punk. My friend Jamie Moses gave me a complete darkroom set-up, and I was all set. With a book, and help from my friend Guillemette Barbet, I learned how to mix chemicals, develop film and print photographs. I continued to work nights at CBGB's until 1978, and took photographs during the day, mostly for *Punk* magazine.

Roberta Bayley,
New York

MAX'S KANSAS CITY & CBGB'S 1976

Debbie and Chris went to CBGB's a lot, especially after they moved to the Bowery. Blondie played at both CBGB's and Max's, but CB's was more of a 'hangout', because it was more casual and drinks were cheaper.

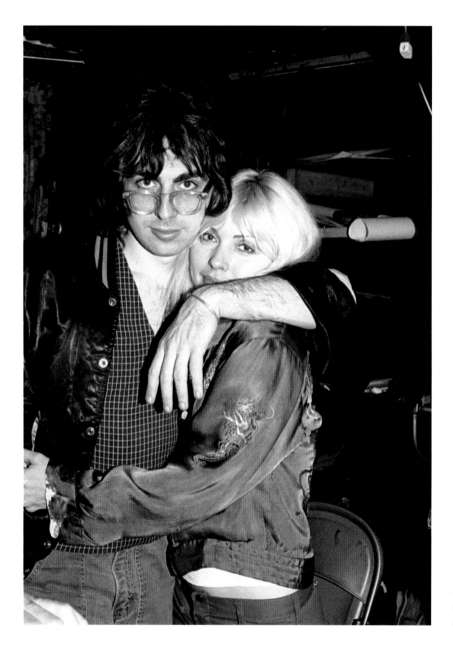

Left: *Debbie and Chris at CBGB's.*
Right: *An early show at Max's Kansas City, where Debbie had worked as a waitress in the late sixties. Even then, Debbie had the monochrome look, while Chris still had his long hair.*

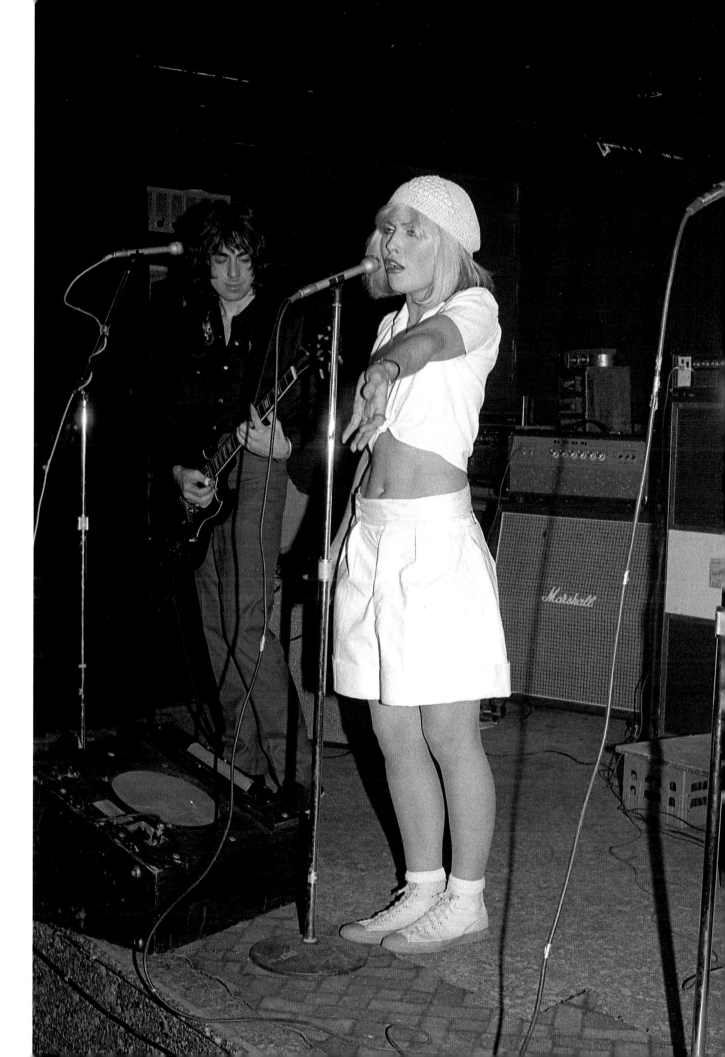

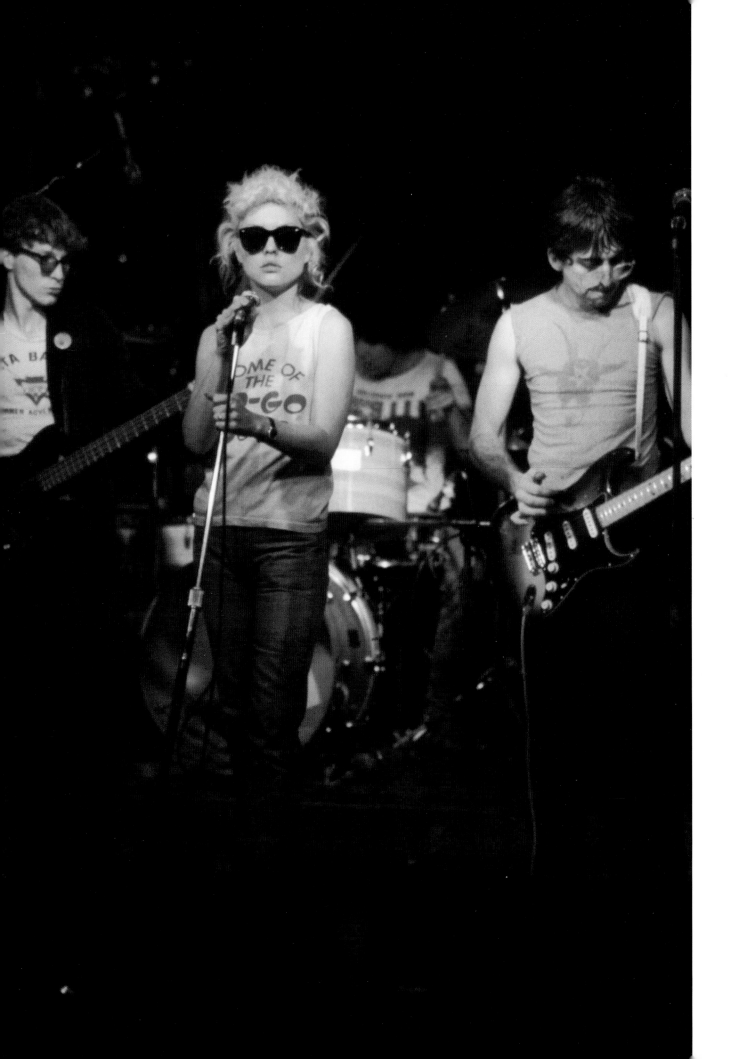

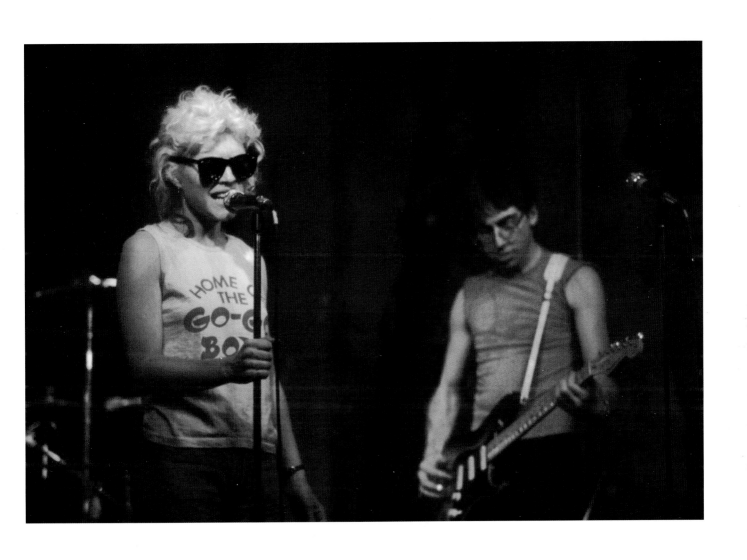

Left: *Gary Valentine, Debbie Harry and Chris Stein during a soundcheck at CBGB's.*
Right: *Debbie always had the best T-shirts.*

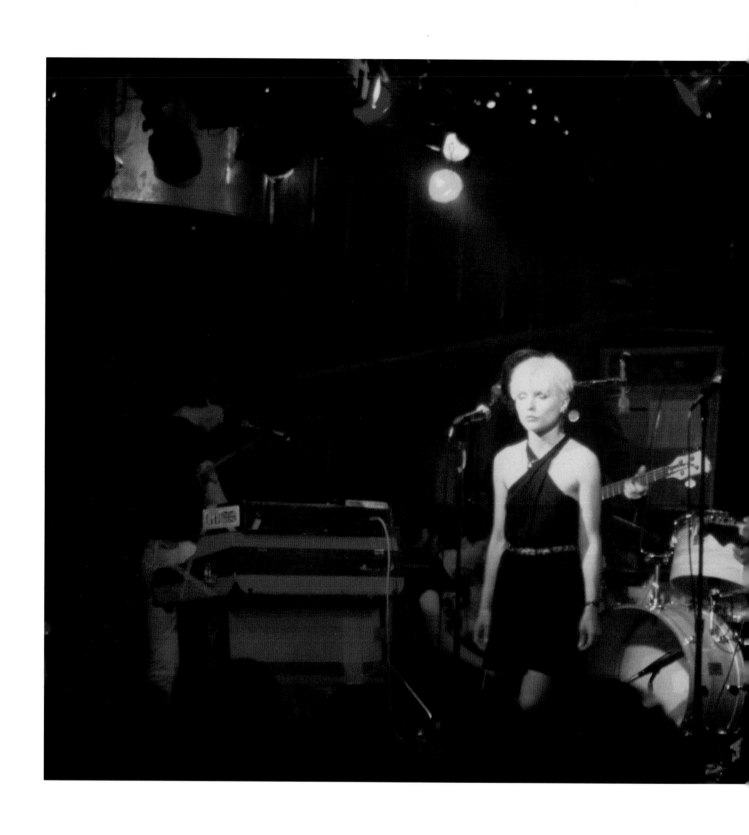

For the show, Debbie changed into a black mini-dress.

All the CBGB's bands wanted to be in *Punk* magazine. John Holmstrom and Legs McNeil had devised ingenious ways to cover the New York music and art scene. They created *fumettis*, or photo comics with elaborate plot lines and crazy characters, which were a lot of fun and resulted in some unusual photographs.

Over the years, Debbie and Chris were enthusiastic supporters of *Punk* and contributed in many ways. Debbie posed for a T-shirt ad and *Punk* centrefold, while Chris wrote articles and gave us his brilliant photos. Debbie had a cameo as a nazi dyke in *Punk*'s 'Nick Detroit' *fumetti*, and later we did one with Blondie, based on their song 'Shark In Jet's Clothing' (titled after the rival gangs in *West Side Story*), for *High Times* magazine.

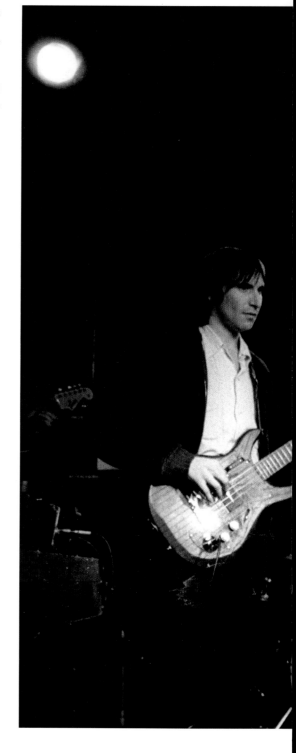

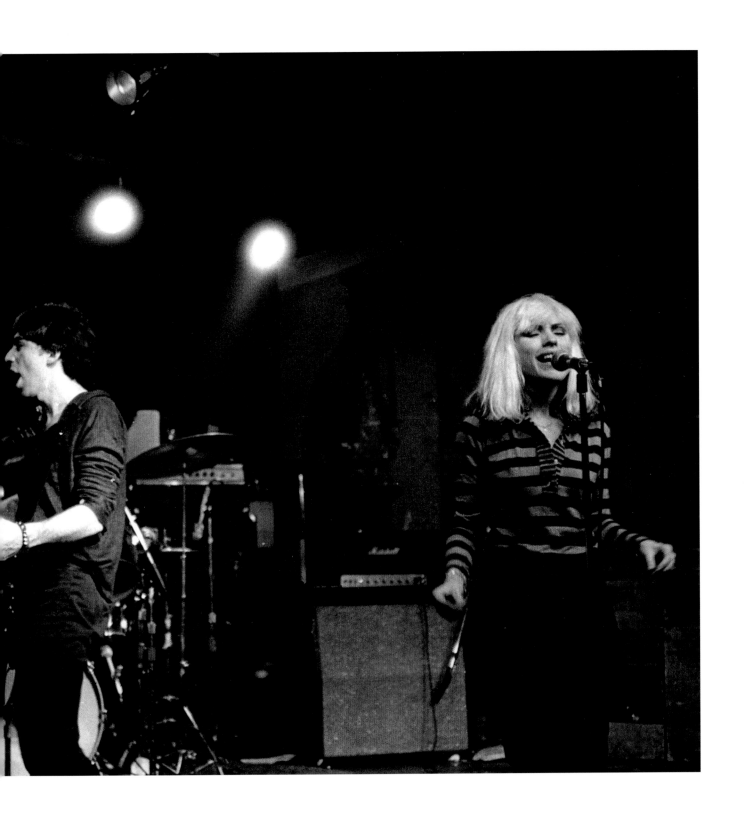

Though Fred Smith had already quit Blondie for Television, he sat in with them one last time at the Punk magazine benefit at CBGB's.

SHARK IN JET'S CLOTHING

A SHORT FILM BASED ON THE SONG BY THE ROCK GROUP BLONDIE!
DIRECTED BY LEGS MCNEIL ★ PHOTOS BY ROBERTA BAYLEY ★ LYRICS © JIMMY (BLONDIE) DESTRI
CAST OF CHARACTERS:
GIRL WHO FALLS IN LOVE WITH SCHMUCK WHO GETS OFFED: **DEBBIE BLONDIE**
SCHMUCK WHO GETS OFFED: **CHRIS (BLONDIE) STEIN**
ASSORTED JUVENILE DELINQUENTS: **GARY (BLONDIE) VALENTINE, CLEM (BLONDIE) BURKE, TOM KATZ + LEGS.**

I ALWAYS HAD MY EYES ON YOU, BUT
YOU CAME FROM ACROSS THE LINE.
I HAD TO MAKE GOOD TIME TO SEE YOU,
YOU HAD TO PAY THE FINE.

ALL THE BOYS ON MY SIDE KNEW
THAT YOU WERE THE SHARK
IF YOU WERE FOUND ON THE BORDER LINE,
YOU'D BE SHOT IN THE DARK.

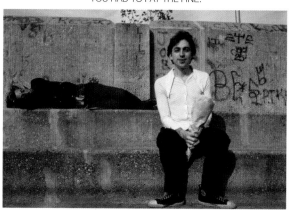

DON'T WEAR THOSE CLOTHES AGAIN
THEY DON'T MAKE IT IN THIS CROWD.
DON'T GO ALL D.T.K., IF YOU DO
YOU'LL WEAR A SHROUD.

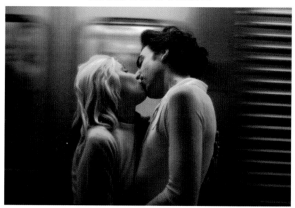

WE'RE MEETING IN A NEUTRAL ZONE,
THE LAST CAR ON THE TRAIN.
THE LOVE YOU BROUGHT, SHAKIN' UP MY BONES
AND CRAWLIN' THROUGH OUR VEINS.

WE ALWAYS MET AT THE EDGE OF A BLADE
AND WE LEFT AT THE END OF A FIGHT.
OF ALL THE GIRLS YOU PLAYED AND YOU MADE,
WHY DID THIS ONE HAVE TO BE WHITE.

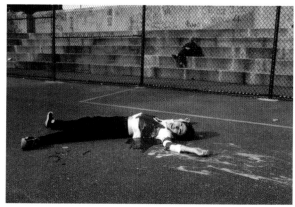

THEY'RE GONNA GET YA THEY'RE 12 O'CLOCK HIGH,
GOT THEIR SIGHTS SET LOW ON YOU.
YOU BETTER BELIEVE ME, I WOULDN'T LIE.
WE BETTER QUIT BEFORE YOU'RE THROUGH.

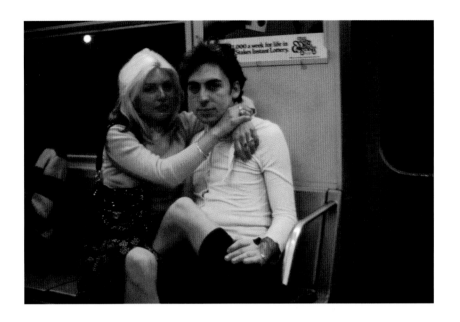

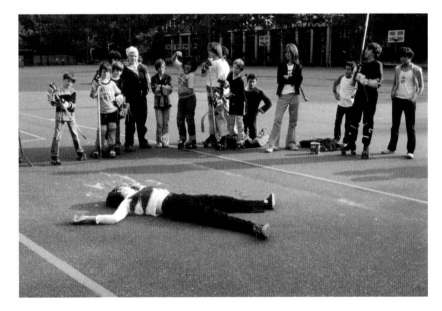

'Shark In Jet's Clothing' was an early fumetti, *shot around same the time as another* Punk *photo story, 'The Legend of Nick Detroit'. We had a lot of fun shooting this. Debbie and Chris were feeling romantic, and the guys had fun playing* West Side Story *characters. The hockey-playing kids in the playground must have thought we were crazy! Jimmy Destri – who wrote the song – didn't show up, so we used Legs McNeil and Tom Katz as extra Sharks.*

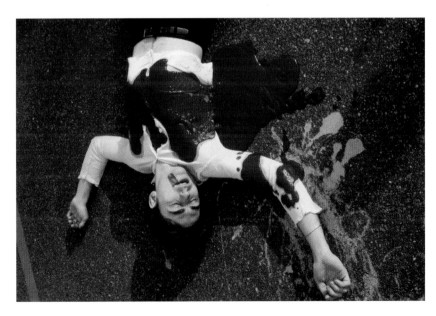

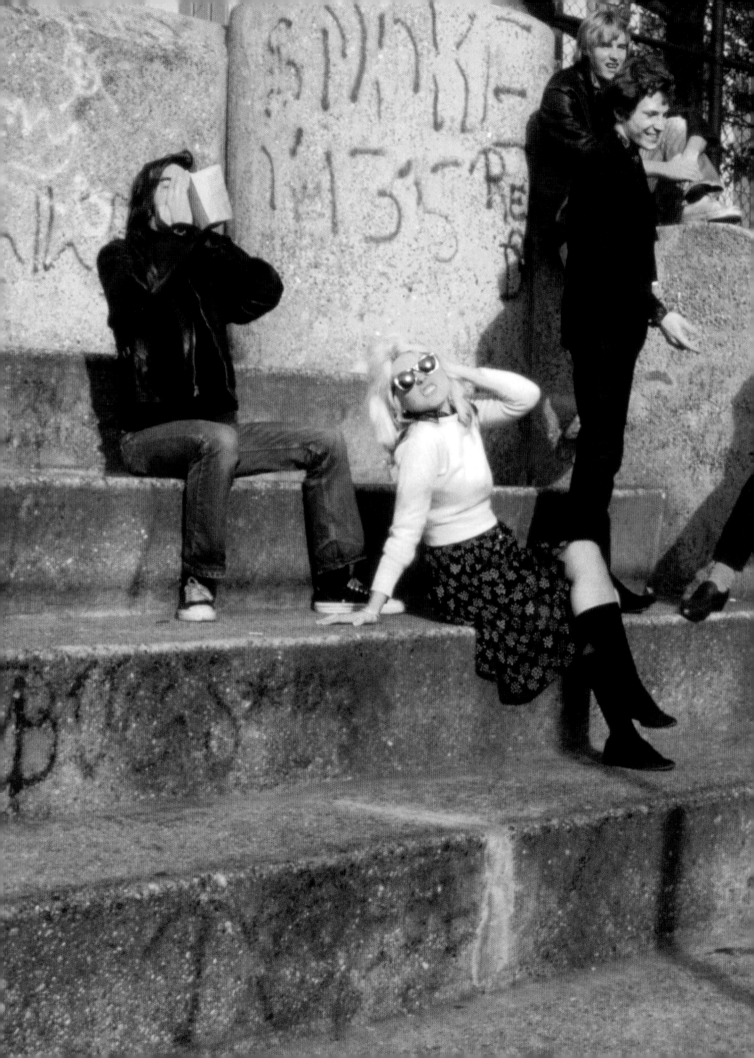

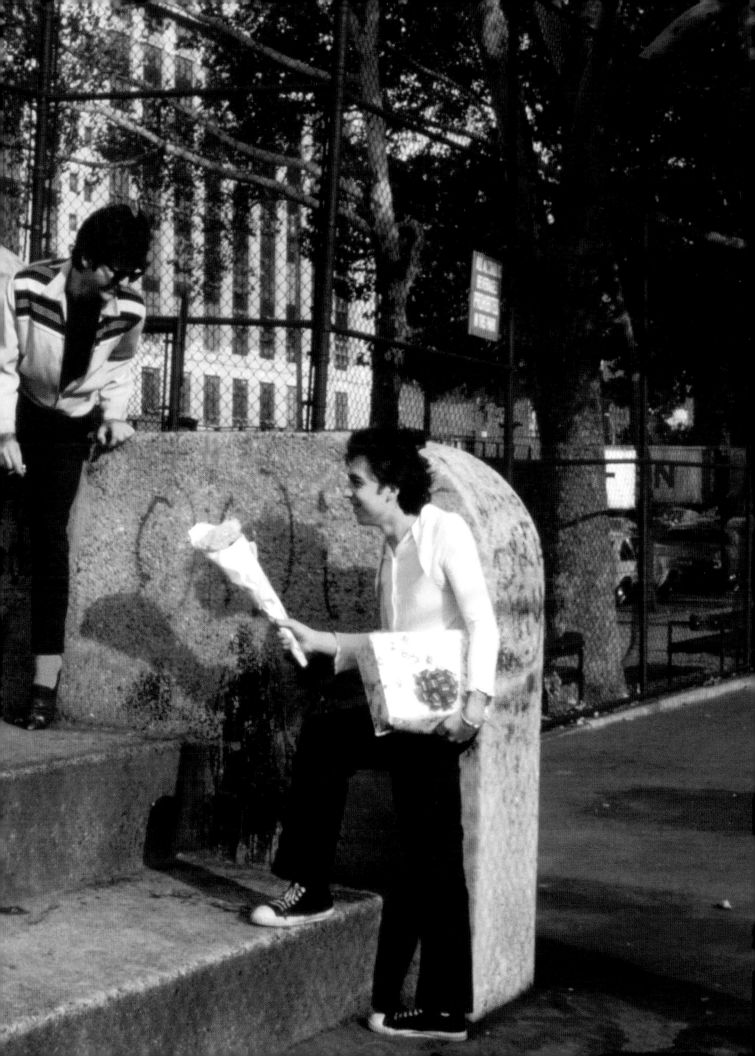

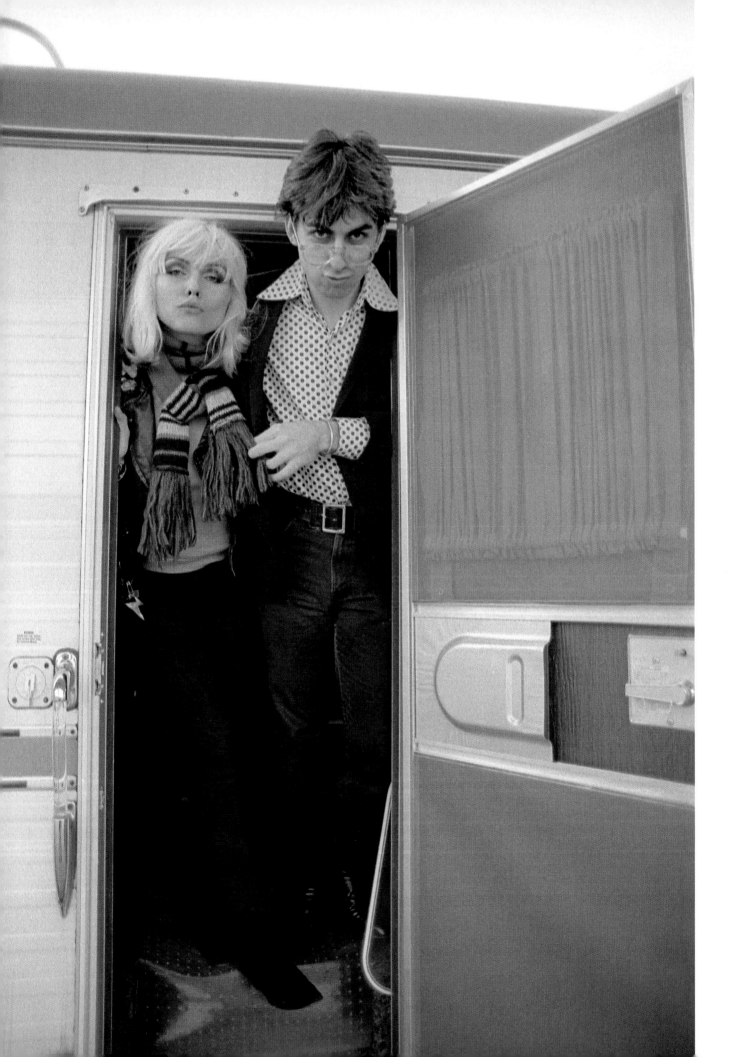

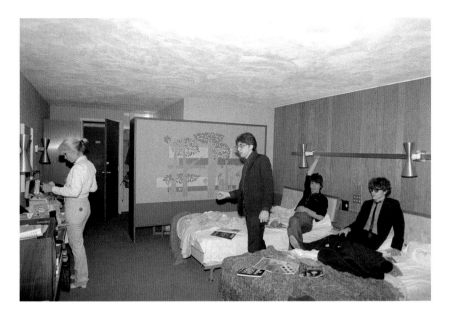

DETROIT

Soon Blondie signed a recording contract with Private Stock Records, which was partially owned by Frankie Valli of the Four Seasons. Their debut record was released in January 1977, and they quickly acquired a manager, Peter Leeds, who had known Debbie in her first band, Wind in the Willows. This gave them someone to book shows, plan tours, and deal with the record company. Leeds' first idea was to establish Blondie in Los Angeles. They became popular there, getting their first airplay from Rodney Bingenheimer at KROQ and gaining a small but devoted fan base. While in L.A., they got word from Iggy Pop and David Bowie that they wanted Blondie to open for Iggy on his US tour. Blondie's appearance supporting Iggy at the Palladium in New York was a triumph, Debbie wearing a red mini with over-the-knee red boots.

Later I travelled to Detroit to see them, staying with my friend Pam Tent. (Pam had been one of the original Cockettes, Sweet Pam, who I'd met in New York when she was Dee Dee Ramone's girlfriend.) Blondie were on a roll, and success seemed inevitable.

Left: Debbie and Chris peek out from the tour bus.
Top and centre: *In Detroit, where Blondie were opening for Iggy Pop, the mood was friendly and relaxed.*
Below: *Jimmy Destri and Gary Valentine.*

PUNK MAGAZINE
MUTANT MONSTER BEACH PARTY

In 1977, Debbie starred with Joey Ramone in 'Mutant Monster Beach Party', a crazed story of star-crossed lovers which featured monsters, bikers, aliens and surfers. Chris took photographs, and also played the role of Debbie's father! This was our most extravagant production so far, with Andy Warhol appearing as a mad scientist, and John Cale, Peter Wolf (of the J. Geils Band) and Lester Bangs as bikers. Future film director Mary Harron appeared as a surfer, and John Waters' star, Edy 'the egg lady' Massey, appeared as Debbie's alter ego. Just about everyone on the downtown New York scene had a role in this extravaganza.

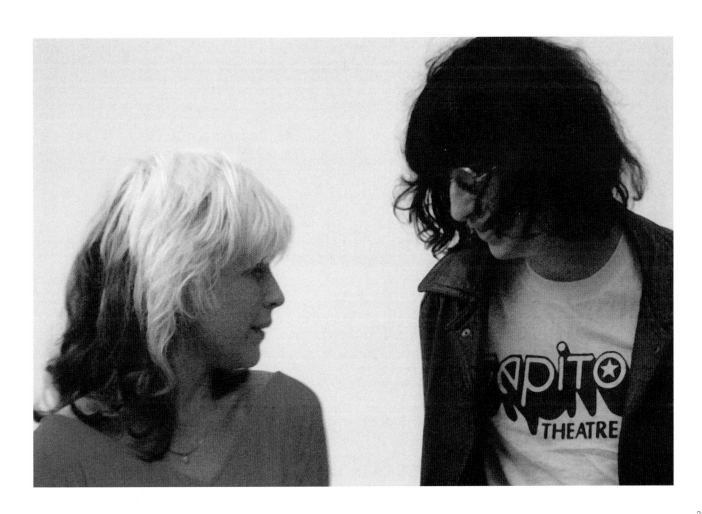

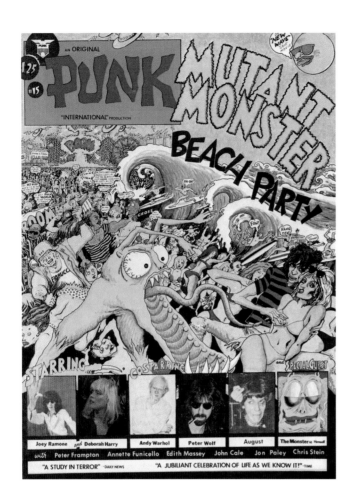

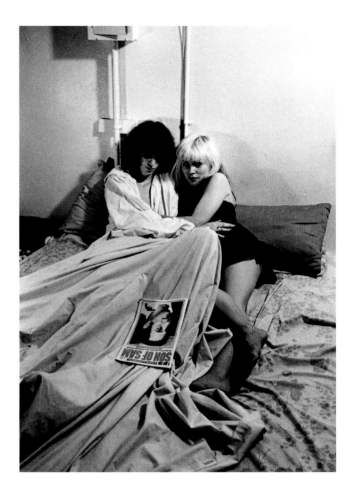

Above left: Cover of Punk *#15, 'Mutant Monster Beach Party' (courtesy of John Holmstrom, publisher and founder of the magazine), our most ambitious project to date.*
Above right: Joey Ramone and Debbie.
Right: Edith Massey appears as the result of Debbie's transformation.

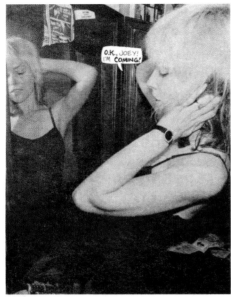

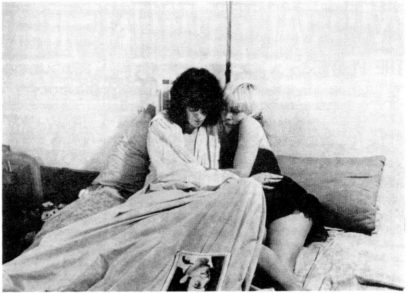

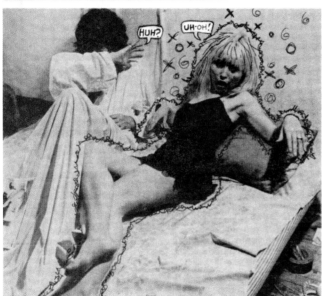

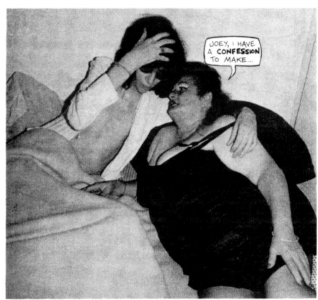

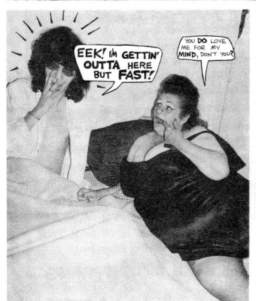

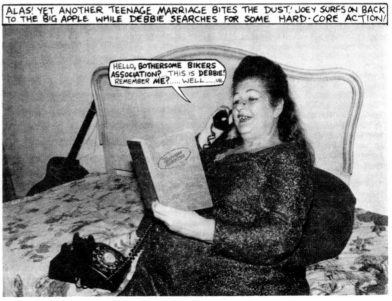

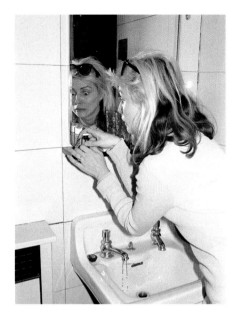
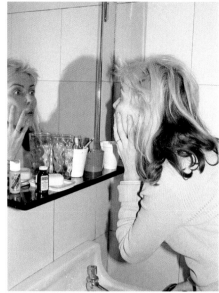
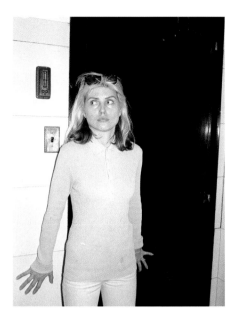
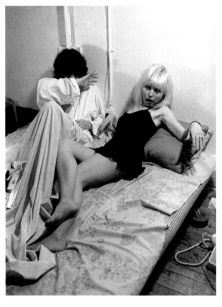
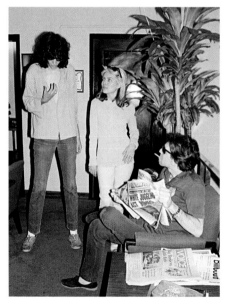
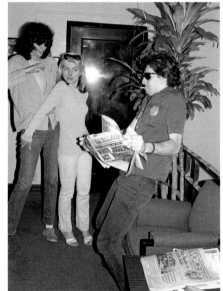

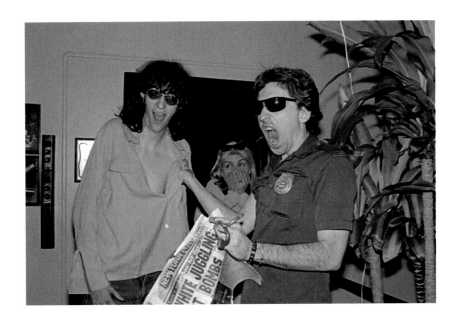

Centre and bottom right: In the 'Mutant Monster Beach Party' wedding scene, Runaway Joan Jett was a bridesmaid and ex-New York Doll David Johansen showed up, unexpectedly, to perform the ceremony.
Following left page: These photos are from 'Mutant Monster Beach Party'. Debbie is waiting for Joey to show up, not realising he's been unjustly arrested for the murder of some children on the beach (who were actually eaten by the monster!).
Following right page: Debbie and Chris appeared on a cable television show in New York called All About Punk, *during the summer.*

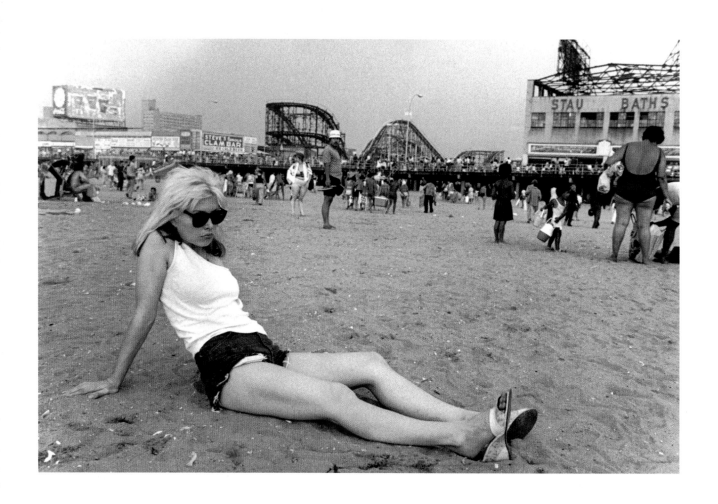

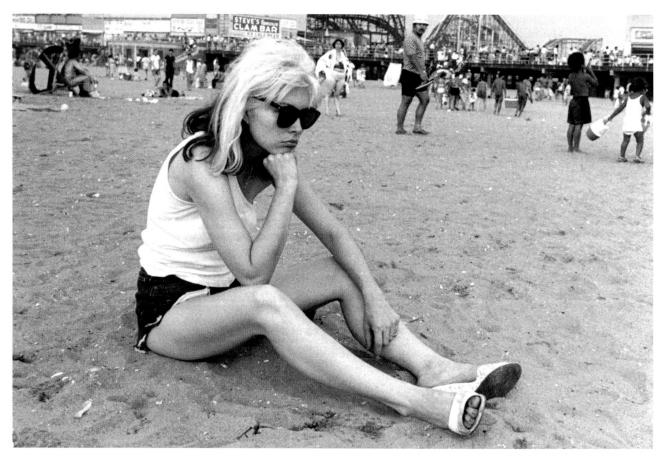

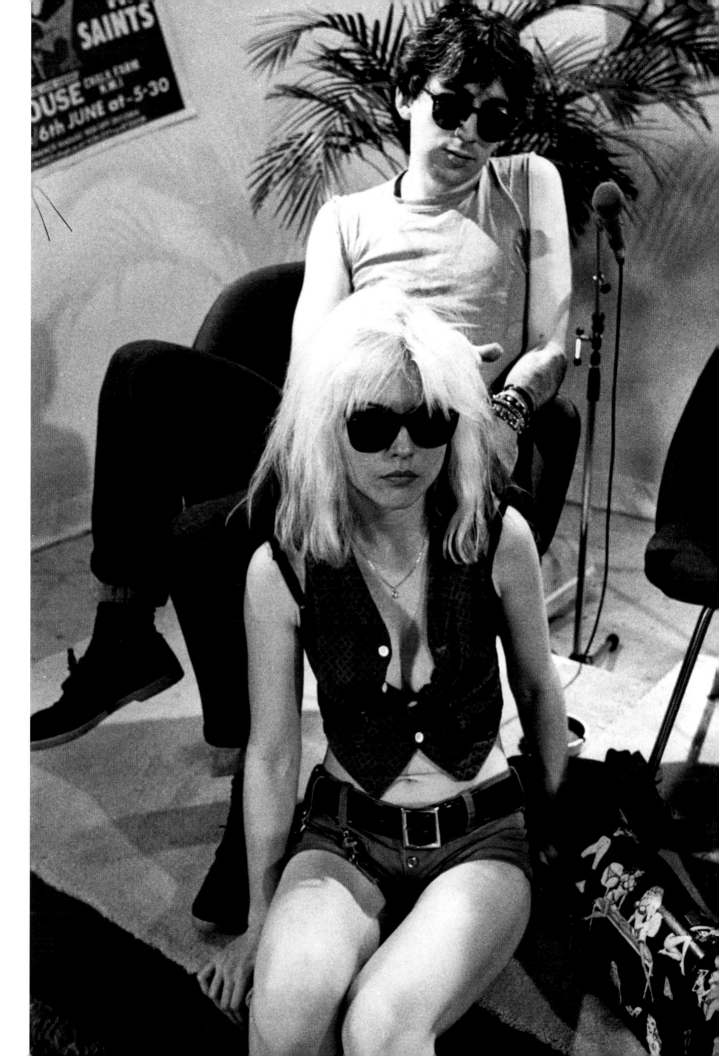

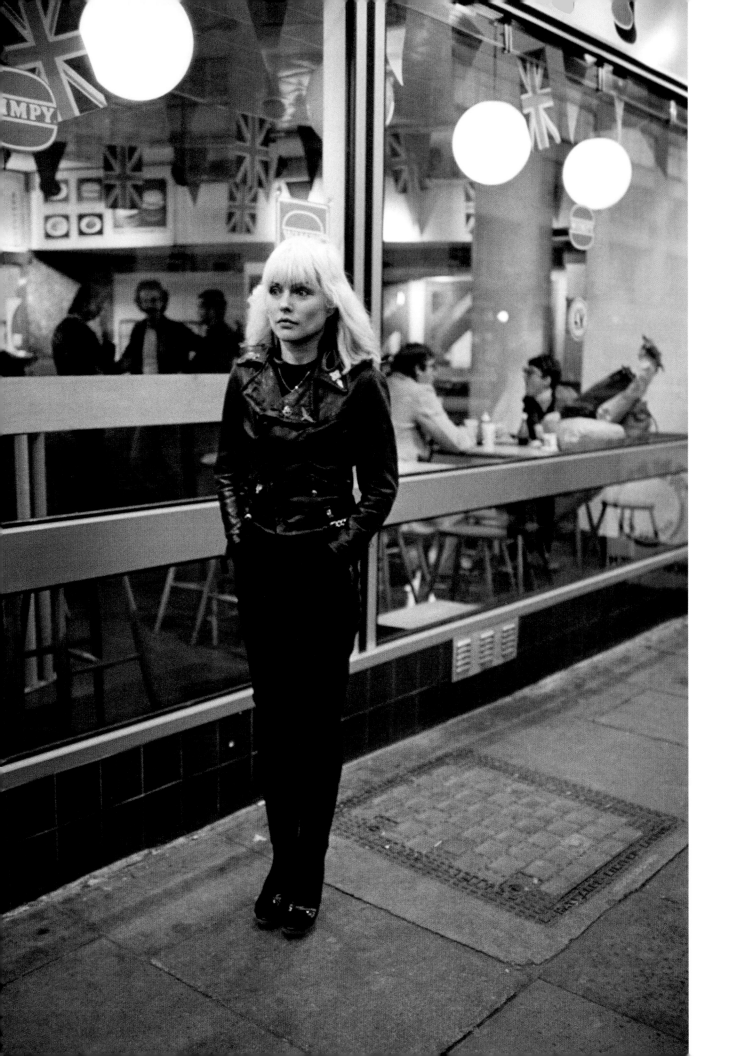

ENGLAND 1977

I went to London in 1977 to check out the punk scene. When I'd left England in 1974, there was nothing going on musically, with the exception of a small pub rock scene. Now, with the Sex Pistols, the Damned and the Clash, there was a whole new thing happening.

Blondie were already popular in England, they had toured all over the country and had a couple of hit singles. They'd been interviewed by every magazine and music paper, appeared on television, and pictures of Debbie and the band were everywhere. When I arrived during November, the members of Blondie were living at the Montcalm Hotel, but not touring. I travelled with them on their tour bus to Manchester, where they filmed a television show. We also saw the Runaways in Sheffield, and Debbie later introduced the band at their Hammersmith Odeon show in London.

Below: In a Manchester television studio, Debbie pits her over-the-knee boots against the map of Italy – and wins, no contest.
Following pages: At the show, she was radiant as always.

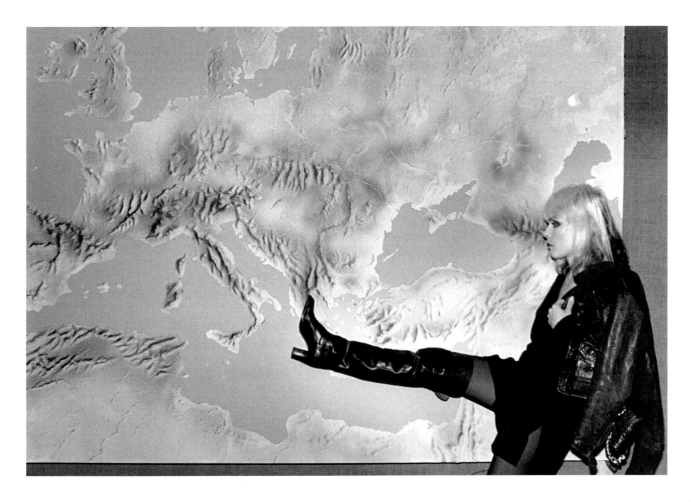

 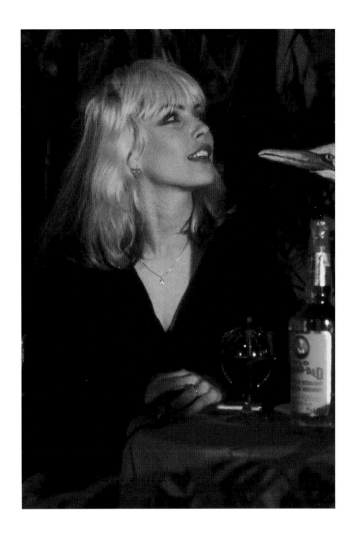

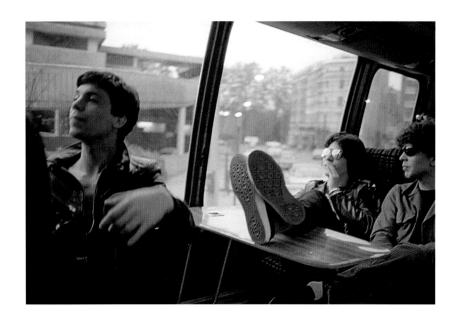

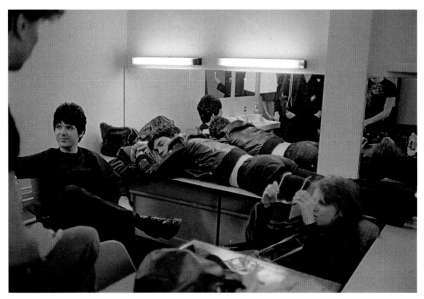

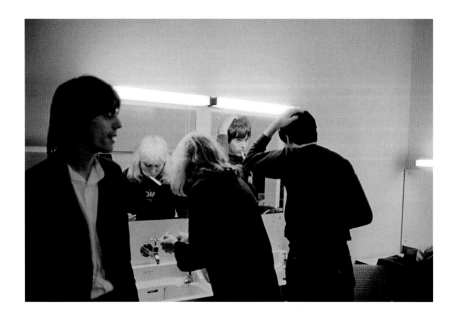

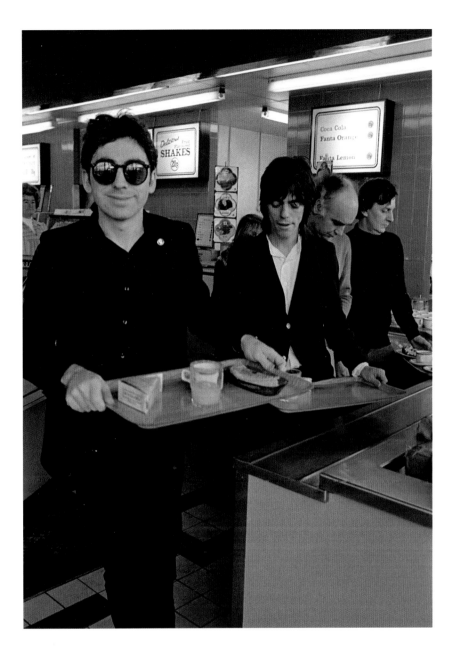

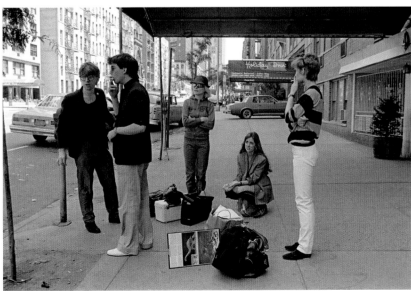

Above: On the motorway in England,
the band stops at a cafeteria for food.

Above: *Waiting – which is what touring is all about.*

Above: *Chris and Debbie on the road.*

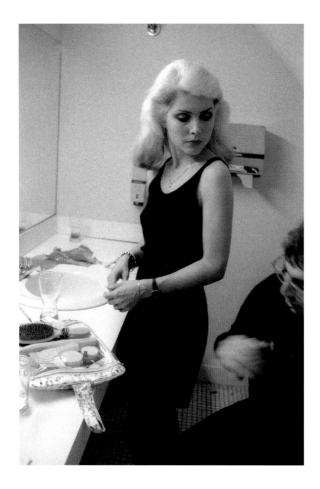
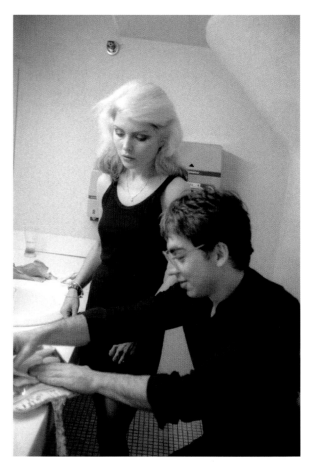
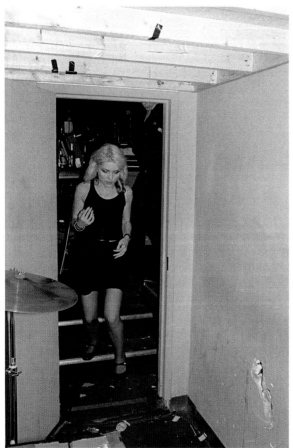

THE PARADISE
BOSTON 1977

During the summer of 1977, New York experienced a major blackout. The next day I called the *Punk* magazine office, and was surprised when John Holmstrom answered the phone. He said he was broke, as the banks were closed, and the local deli had refused to give him a sandwich despite his being a regular customer. My father was flying into New York that day, and I told John I would happily buy him lunch if we could walk uptown to the Algonquin on 44th Street, where my father was staying. After we had a couple of drinks with my dad, we began calling downtown to see if the electricity was on, but the East Village was still dark. Then we called Debbie and Chris on 17th Street; they said they had electricity, and to come on over. Iggy showed up with the tapes of his new album, which he'd just finished with Bowie in Berlin. It was a memorable day. Later that summer I also travelled with the group twice to Boston, where they played the Paradise with David Johansen and Television supporting them.

Blondie had a lot of fans in Boston, and their shows there were sold out. Having old friends such as Fred Smith of Television and David Johansen open for them also added to the relaxed atmosphere.

Following pages – lower left:
Backstage at the Paradise, support act David Johansen shares a mirror with Clem.
Following pages – lower right:
Musician/producer Andy Paley, then of the Paley Brothers, comes backstage to welcome the band.

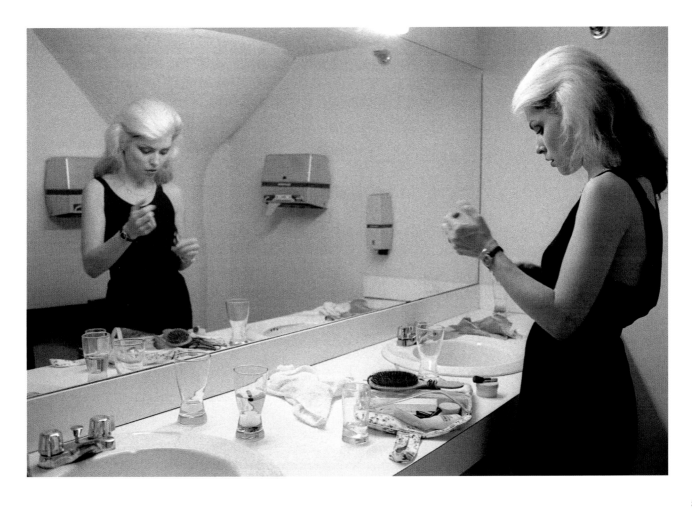

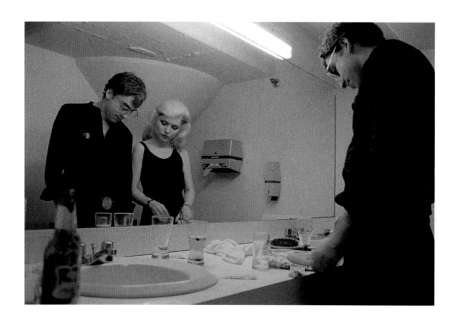

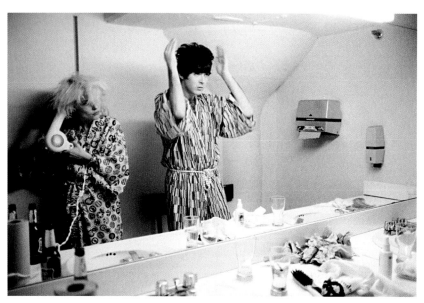

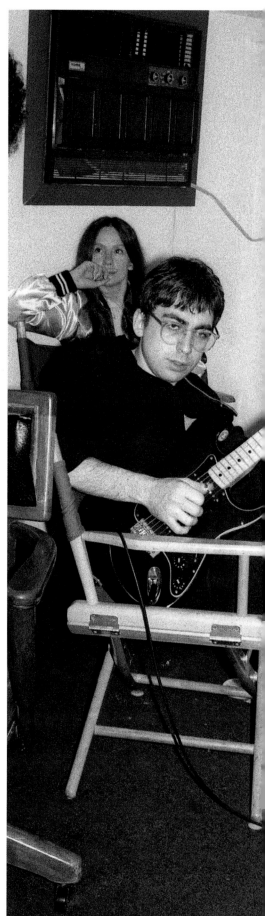

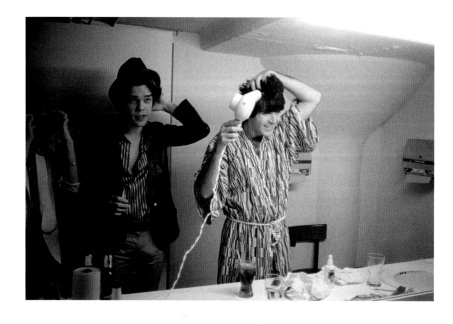

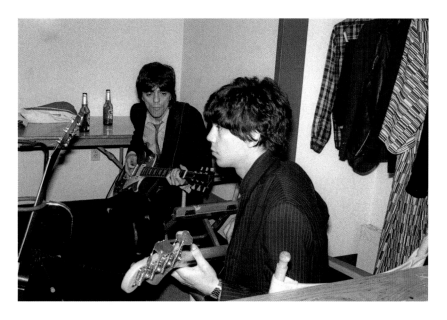

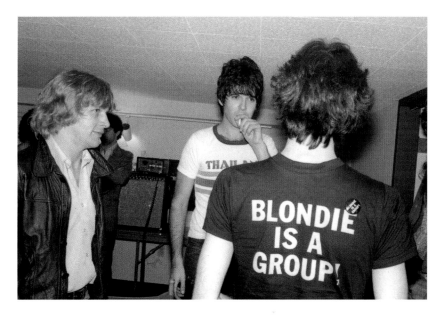

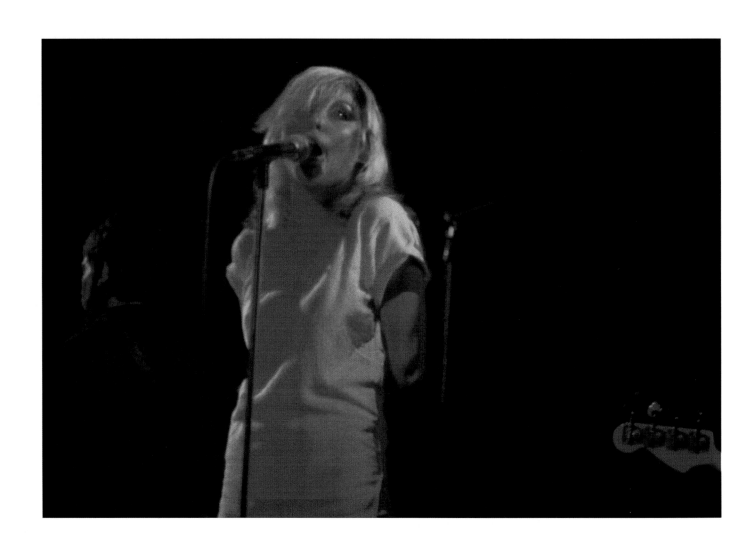

The Paradise is Boston's premiere
showcase club, and Blondie played there
twice – once with Television opening, and
once with David Johansen. Debbie wore a
black mini-dress for the first group of shows,
and a white mini-dress with athletic knee
protectors for the shows with Johansen.

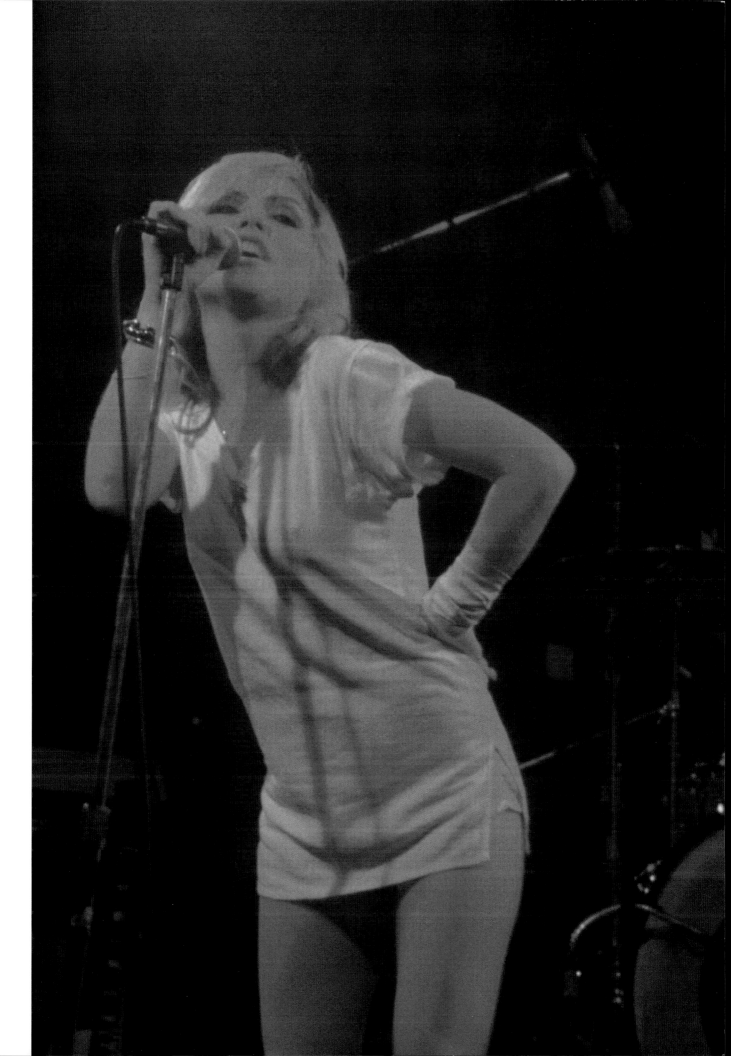

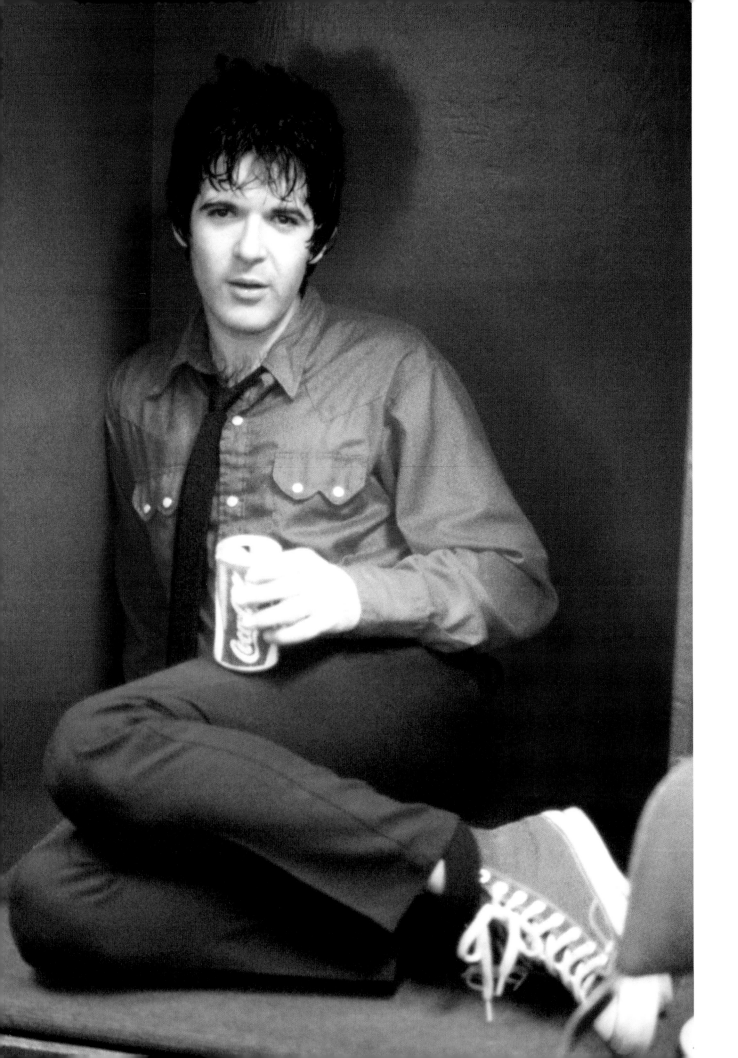

THE PHILADELPHIA SPECTRUM 1978

Gary Valentine had left the band after the first album, and, during the recording of *Plastic Letters*, another friend of Clem's, Frank Infante, would join – first as a bass player, later switching to guitar. In 1977, Private Stock was bought out by Terry Ellis of Chrysalis Records. The band added Nigel Harrison, who they'd met in L.A., on bass, and began planning for their third album, which would be called *Parallel Lines*.

Around that time, Blondie's manager, Peter Leeds, asked me if I would like a job in his office, assisting their West Coast publicist 'Famous' Toby Mamis. He paid me $125 a week. I had the crummiest tiny second-hand desk, in the middle of a big office full of people who were part of some hospital management company. Blondie were Leeds' sideline or something, I never understood what the deal was. Luckily for me, Leeds had a great secretary, Meg Winthrop, and another woman who

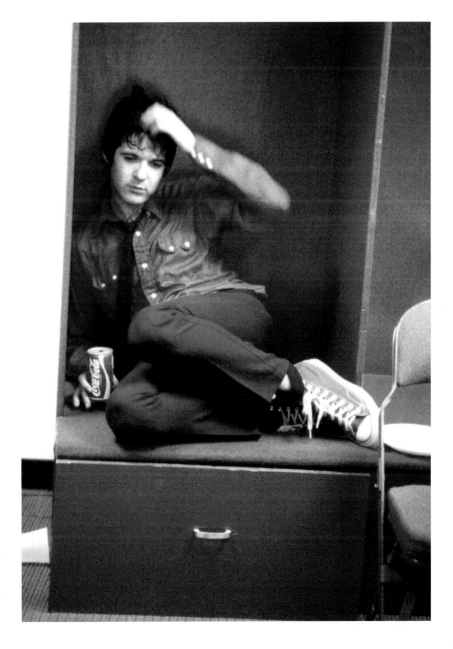

From the moment he joined Blondie, Clem was the most enthusiastic member of the band. He was always appreciative of the fans, being such a music fan himself. His high energy drumming and dedication to rock and roll was the X factor that made Blondie so successful over the years.

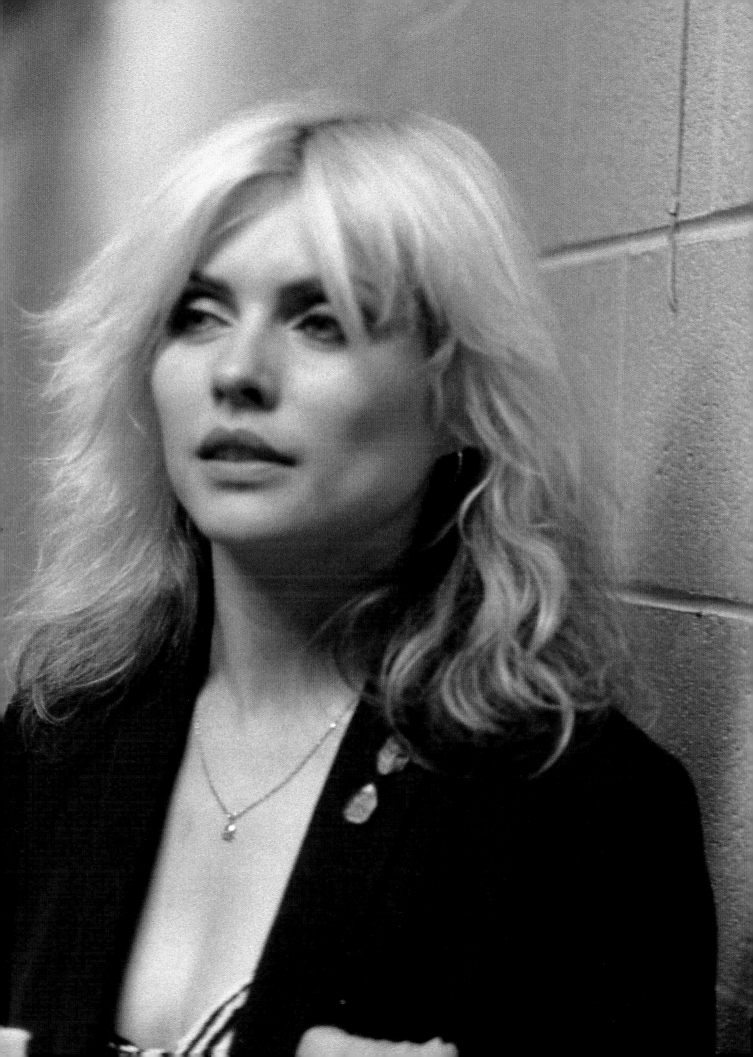

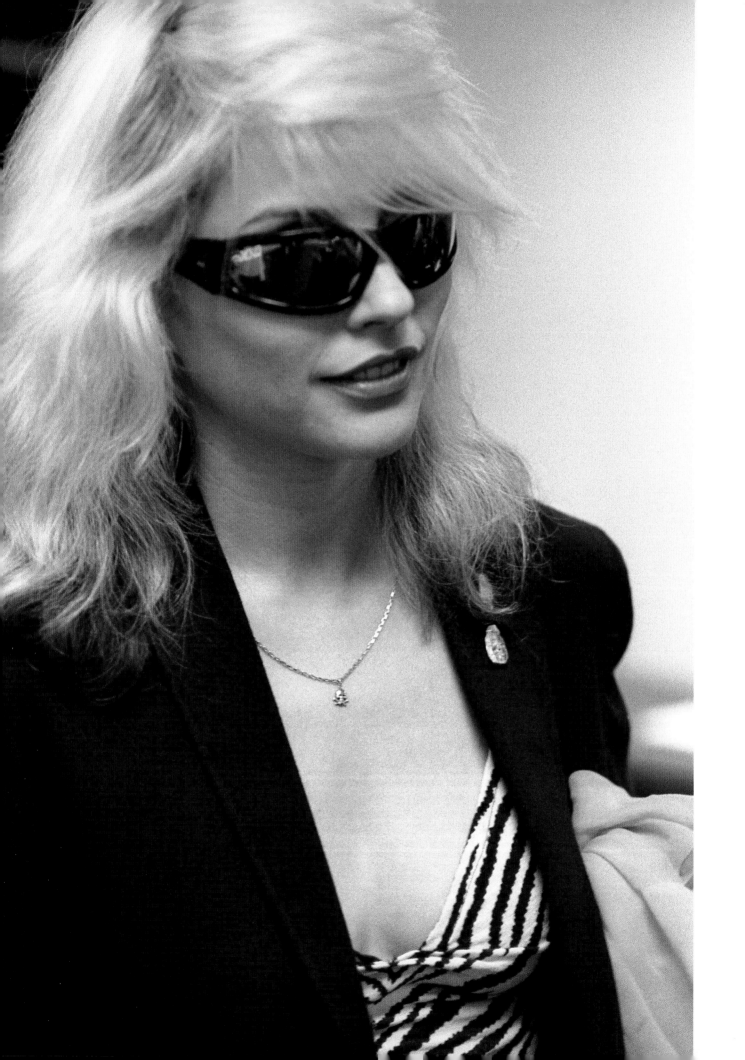

worked there, named Constance, was also very helpful. I'd never worked in an office before, didn't type or know how to use a telex machine (this was long before PCs), but somehow, with Meg's help, I got by. Blondie were already beginning to have success in Europe and Australia, and Leeds financed an international tour while Toby Mamis and I held the fort.

One of my jobs was to create the Blondie fan club. Leeds was smart enough to understand the concept of merchandising, and how much income it could generate. A fan club would provide a list of Blondie devotees who would be likely to purchase T-shirts and other paraphernalia. With the help of the *Punk* staff, we created an original fan newsletter – much more interesting and personal than the usual fan stuff.

Problems between the members of Blondie and Leeds began developing early on. The main problem was a lack of respect – in Debbie's words, he treated them 'like children'. Debbie and Chris were over 30 by now, and certainly not about to have someone dictate to them. They had their own ideas about the direction of Blondie, but Leeds seemed to have a desire to separate and alienate the other band members. It certainly would have been easier to control one performer instead of five, but Blondie were a group, a collective. Everyone but Clem wrote songs, and, while Debbie and Chris were certainly the 'leaders', they didn't want the others to feel like outsiders. Being in a band is always stressful, but if an outside force is fanning the flames of dissent, it gets really bad.

Right: Jimmy Destri's girlfriend, teenage drummer Laura Davis from the Student Teachers, applies last-minute makeup to her man.

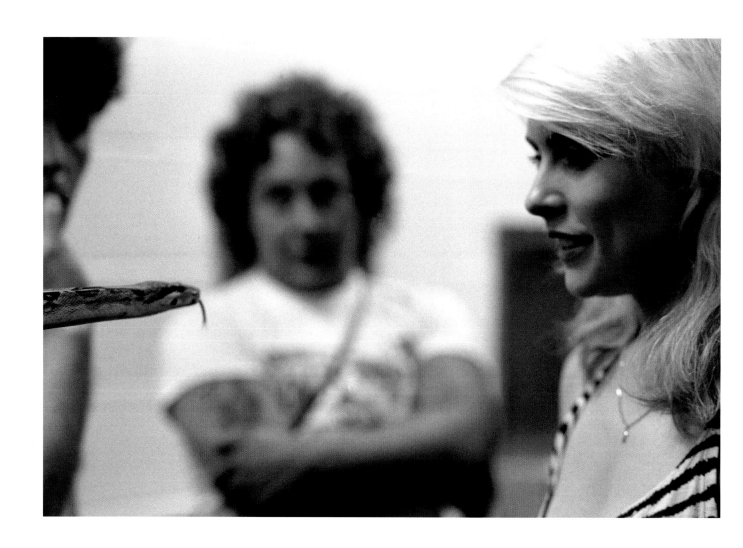

The shows with Alice Cooper at the Philadelphia
Spectrum were Blondie's biggest to date, playing
to 20,000 people in a sports stadium. Blondie
and Alice shared an agent, the legendary Jon
Podell, who thought Blondie would be the
perfect opening act for the shows.

Above and right: Alice Cooper had a huge
snake that he used for a prop in his act.
It visited Debbie backstage before the show.

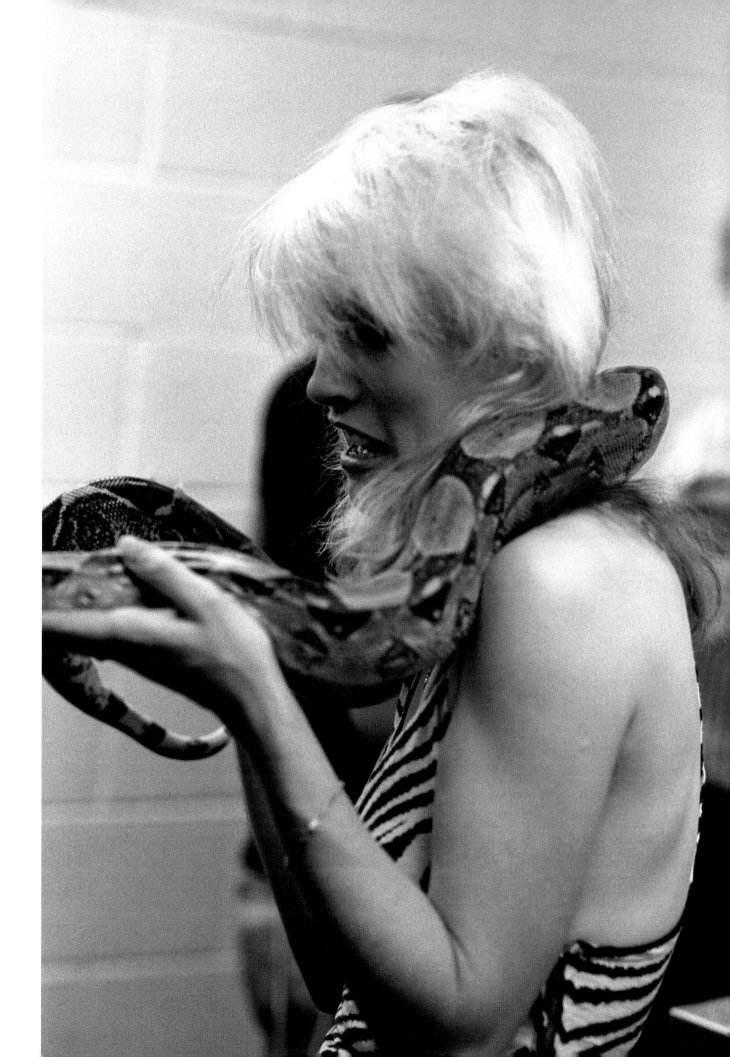

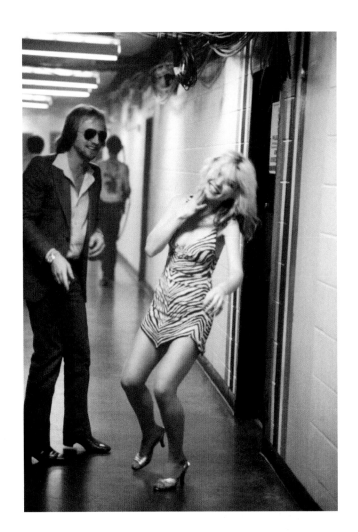

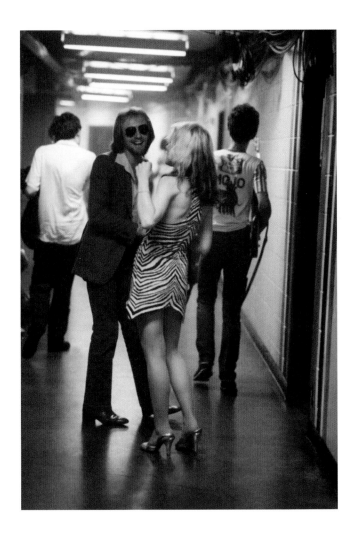

Above: Debbie and producer Mike Chapman
having fun after the concert. For the first show
Debbie wore her famous zebra print dress, which
was actually made from a pillowcase found in the
trash! Debbie had worn this dress in the 'Creem
Dream' centrefold for Creem *magazine, and also
for a legendary show at Max's Kansas City,
where she sang in German à la Marlene Dietrich.
Luckily, this amazing show was filmed for
posterity by Bob Gruen.*

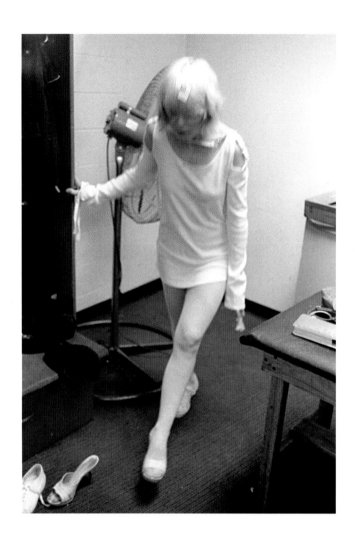

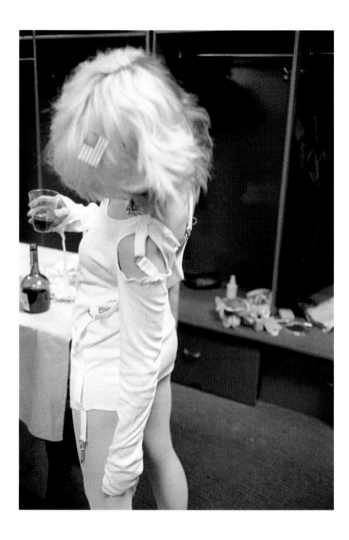

For the second show in Philadelphia, Debbie wore a bondage-influenced mini-dress from the London store Boy. She debated whether to wear her Paradise Bootery 'Marilyn' heels (the ones she wears on Parallel Lines) *or more practical sneakers. In the end, she wore the heels for her entrance, and later changed between songs to the sneakers!*

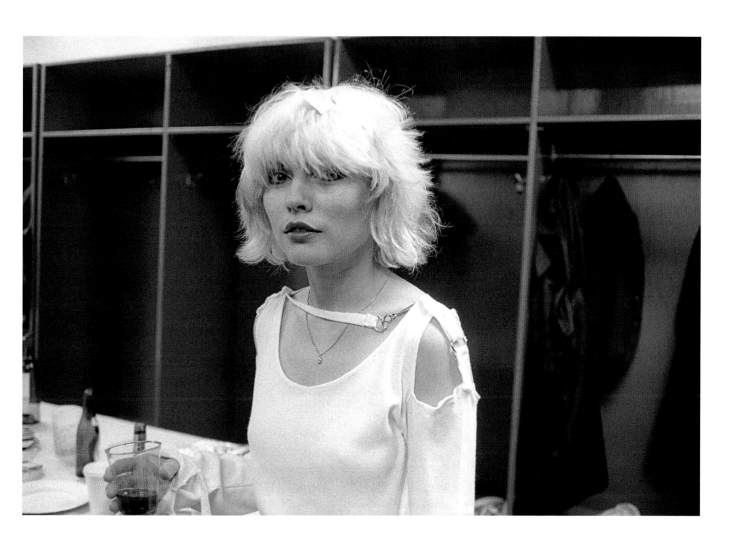

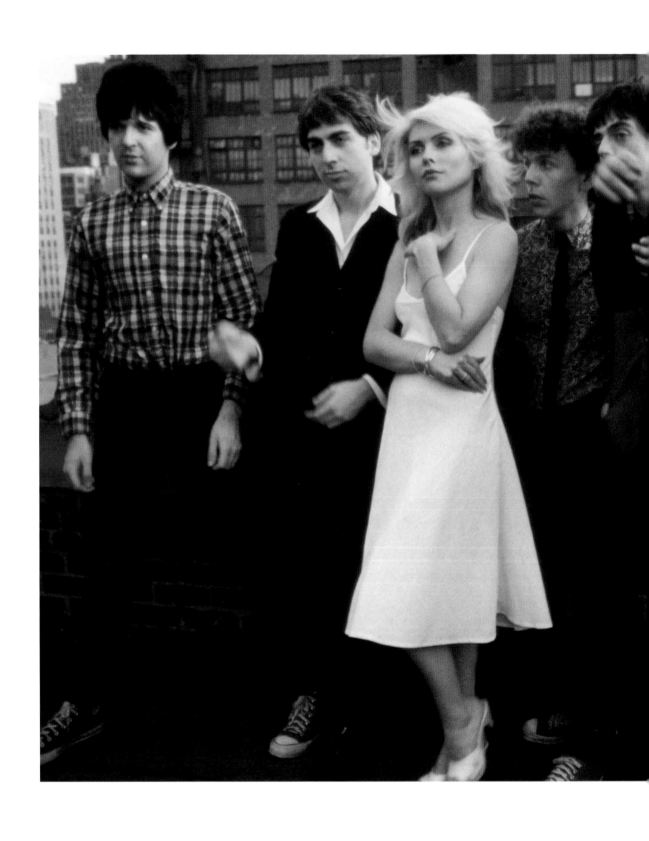

Left to right: *Clem Burke, Chris Stein, Debbie Harry, Nigel Harrison, Frank Infante and Jimmy Destri. The pictures from this session became famous all over the world.*

UP ON THE ROOF

When the band returned from its lengthy five-month world tour, everyone was completely burnt out. They had visited Australia, Thailand, Japan and Europe. Peter Leeds had put everyone on a salary of $125 a week, barely enough to buy food, let alone pay rent! Debbie and Chris moved into the Gramercy Park Hotel, and later Southgate Towers, then inexpensive residential hotels. Imagine being successful in a dozen countries, having played all over the world, with hit records, even a number one, and you're still broke! I'm not the only one among their friends who remembers lending them money around this time. It was depressing, to say the least. Debbie and Chris did a tour of US radio stations, and the DJs finally began to warm to Debbie's charms, and Chris's droll wit – but still, amazingly, a record deemed appropriate for American radio couldn't be found in their repertoire.

In June 1978, Blondie began recording with producer Mike Chapman. Chapman was charmingly insane, but a disciplined perfectionist in the studio. The band really developed under his hit-making tutelage. By the time *Parallel Lines* was finished, everyone was convinced the record could break into the American charts. While Blondie had had hits in Europe and Australia, including number ones, American success had eluded them. American radio had strict play lists and was not open to anything new. In addition, Blondie's association with the punk movement actually made them frightening to disc jockeys! Even with Debbie's looks and Blondie's super commercial sound, no one would play their record.

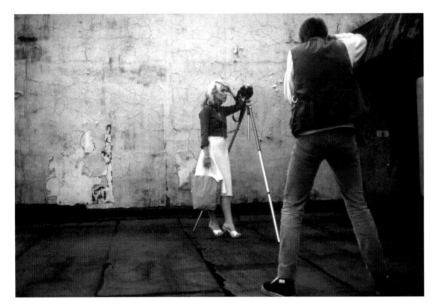

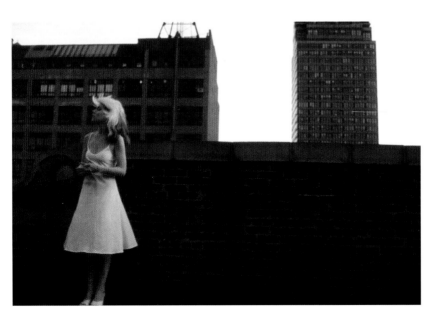

British photographer Martyn Goddard shoots Blondie on a roof in midtown Manhattan. The behind the scenes photos were taken by me.

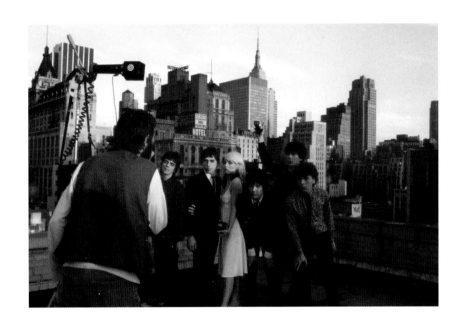

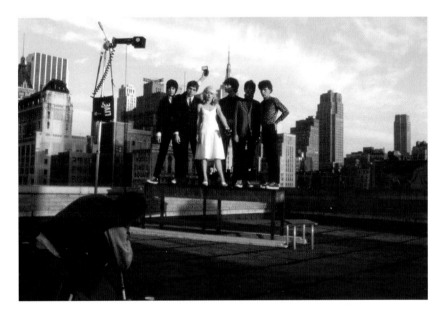

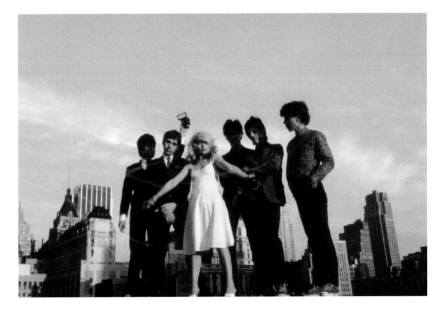

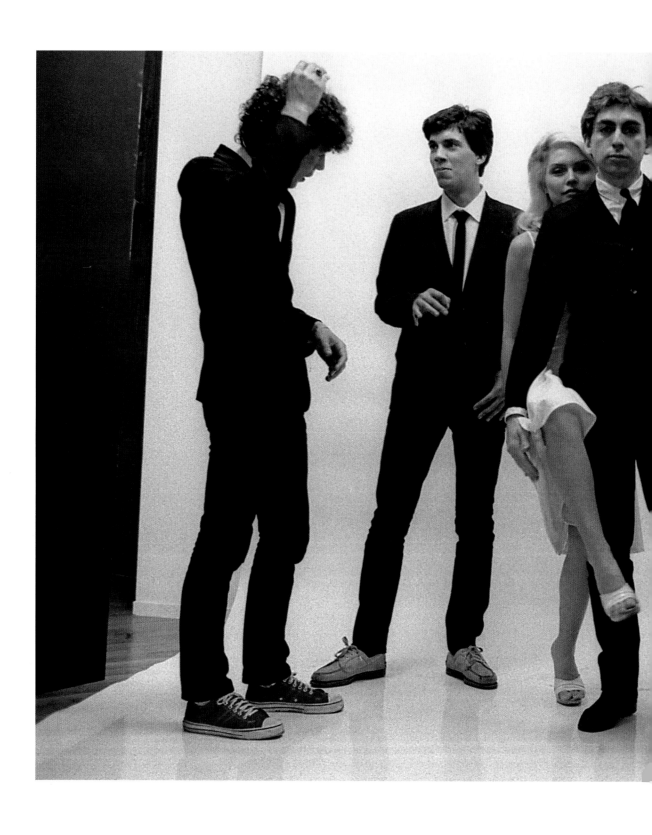

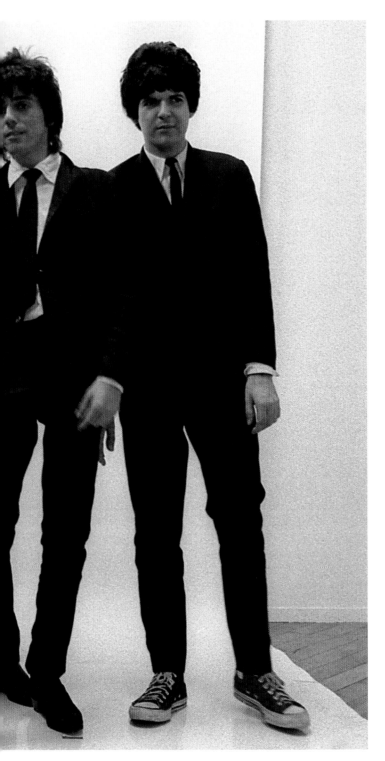

PARALLEL LINES

For the cover of *Parallel Lines*, I enlisted the coolest downtown photographer I knew, Edo Bertoglio. Peter Leeds had hired some 'big name' photographer for a lot of money, but everyone hated the photos. So we had a budget of $400 for Edo. His French girlfriend, the divine Maripol, was the stylist. Because it was deemed impossible to get a single shot of all five band members which everyone would like, the musicians were photographed individually. The finished photos were given to each member, and they marked those of themselves they wanted used. It would have been a great solution, except that Leeds ignored their choices completely and selected the images *he* wanted! It was definitely the beginning of the end.

After *Parallel Lines* was released, Debbie and Chris finally got an apartment on West 58th Street, a small penthouse with a terrace. It was affordable, but they still had to get someone to co-sign the lease, as they didn't have credit. Although the band had been touring non-stop for years and had hit records in Europe and Australia, they still hadn't seen any of the money. It was an extremely frustrating period.

Around this time, Debbie auditioned with Martin Scorsese and Robert De Niro for *Raging Bull*, wearing a red cashmere sheath made by her friend Stephen Sprouse. But all the Blondie stress had diminished her moxie, and she felt she didn't do well at the audition. (Bronx-born newcomer Cathy Moriarty got the part, but to me she was just like Debbie onscreen.) Many musicians want to be actors, believing that their charisma will translate onto the screen. But the two mediums are very different, and each requires a lot of concentration. It's hard to do both, especially if you're untrained.

Debbie, however, did well in the roles she took on, first in Amos Poe's underground classics, and later in *Union City*. My favourite is David Cronenberg's *Videodrome*, where she played a sexy radio talk show host. Debbie also made a successful showing in a three-part episode of *Wise Guy*, the eighties television show starring Ken Wahl, where she played a washed-up pop star Wahl discovers singing in a New Jersey dive. Now, of course, she has a second career as a respected film actress, due to her success in independent films such as *Heavy*.

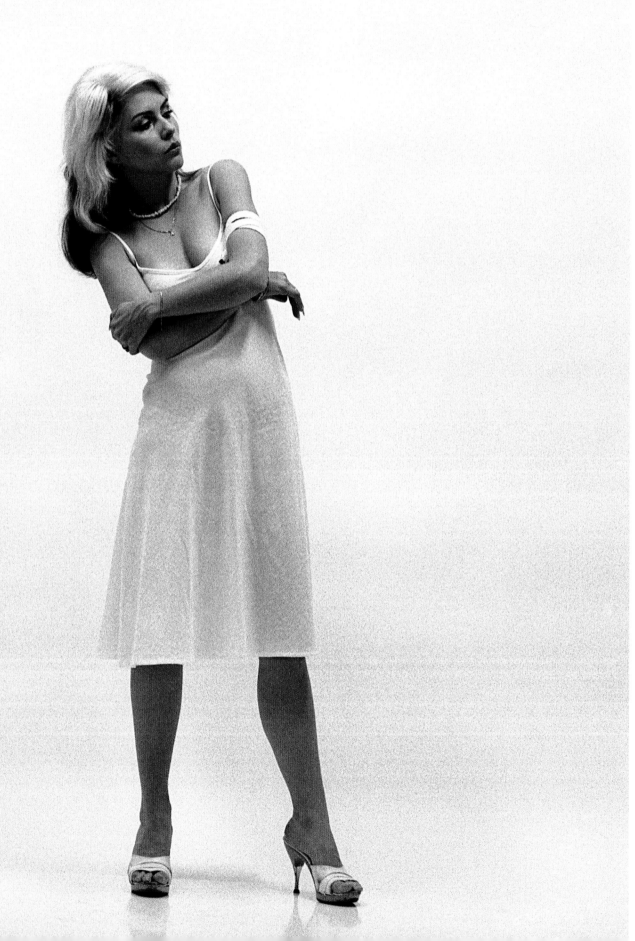

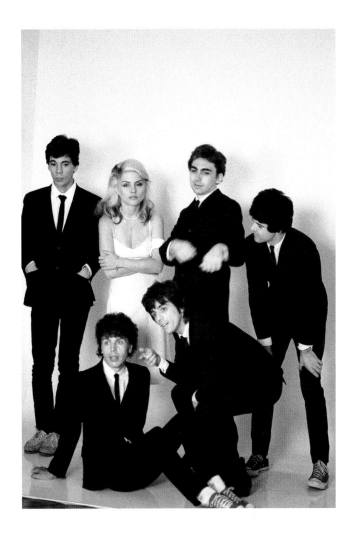

Above left: Maripol tried to get Debbie to go for a mini look on the Parallel Lines *shoot, but failed!*
Following pages: On this contact sheet, we can see Peter Leeds, Blondie's manager, with Jimmy Destri (19A), and the photographer herself (13A).

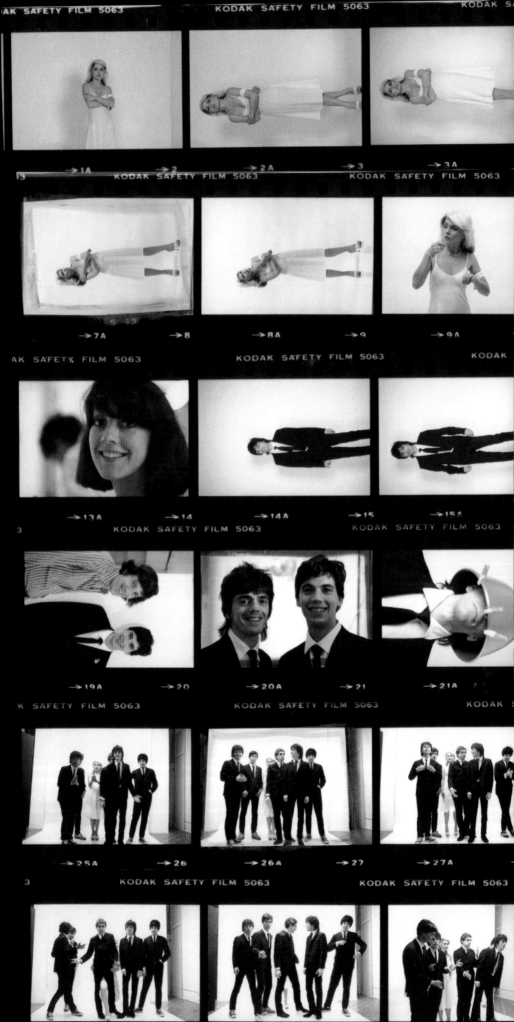

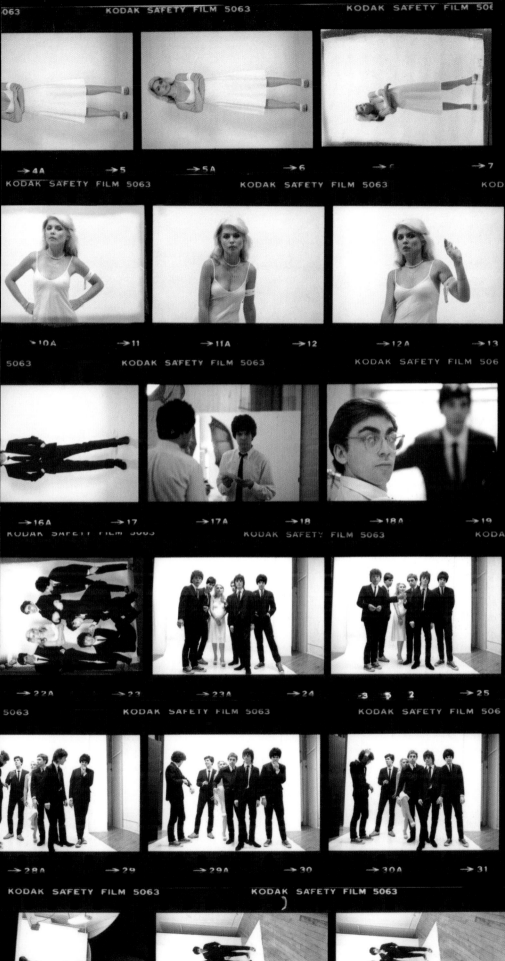

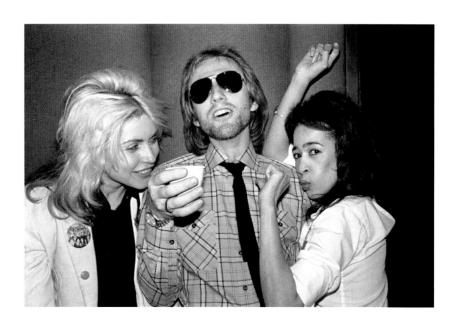

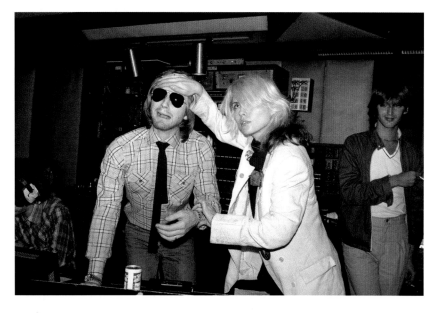

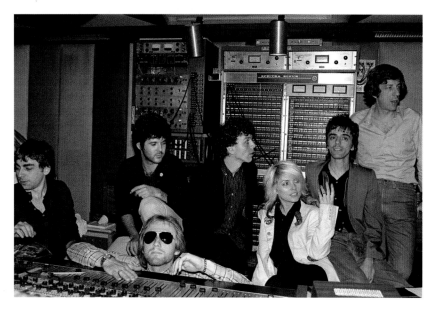

Top: *Debbie and guest vocalist Ronnie Spector ham it up for the camera, with producer Mike Chapman.*
Bottom: *In the studio with producer Mike Chapman and manager Peter Leeds.*

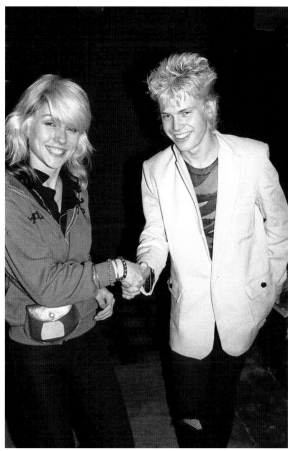

Top: Ronnie and Debbie strike a pose.
Bottom: Billy Idol stopped by to say hello.

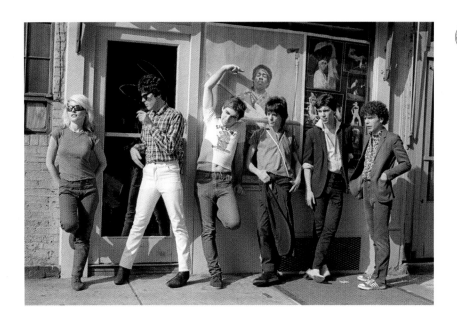

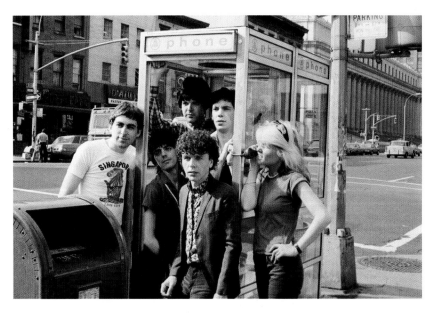

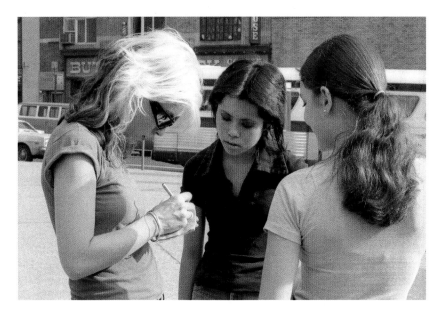

Taking a break from recording, Blondie did an off-the-cuff photo session for a European magazine.

Bottom left: *Debbie stopped to give an autograph to a fan.*

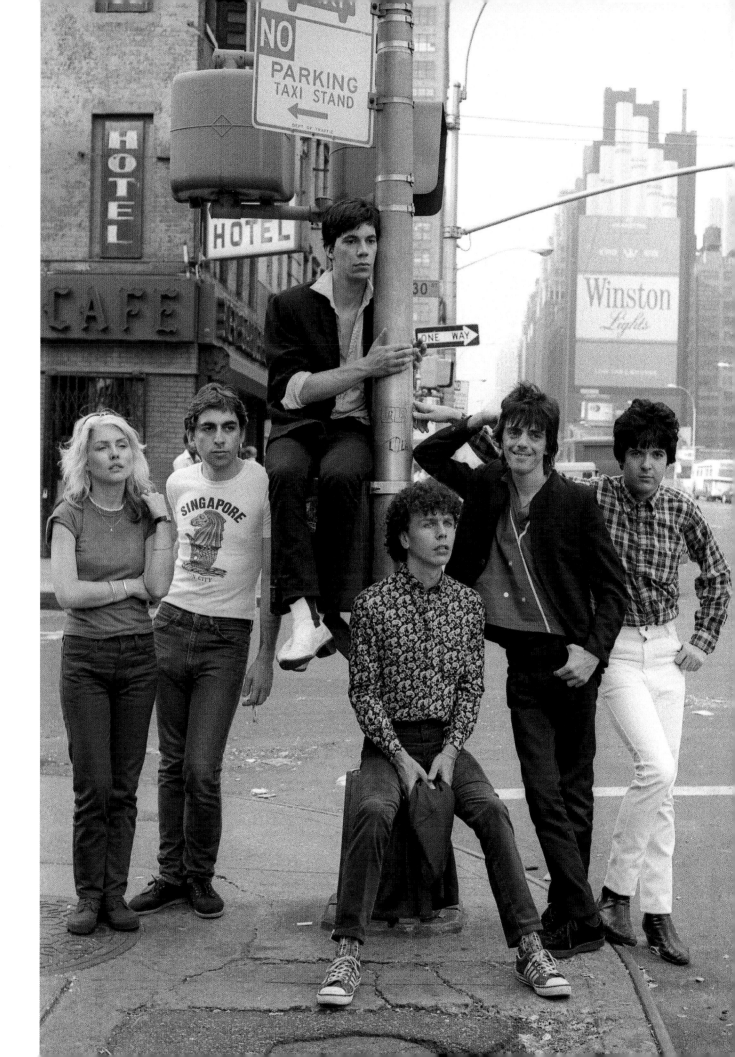

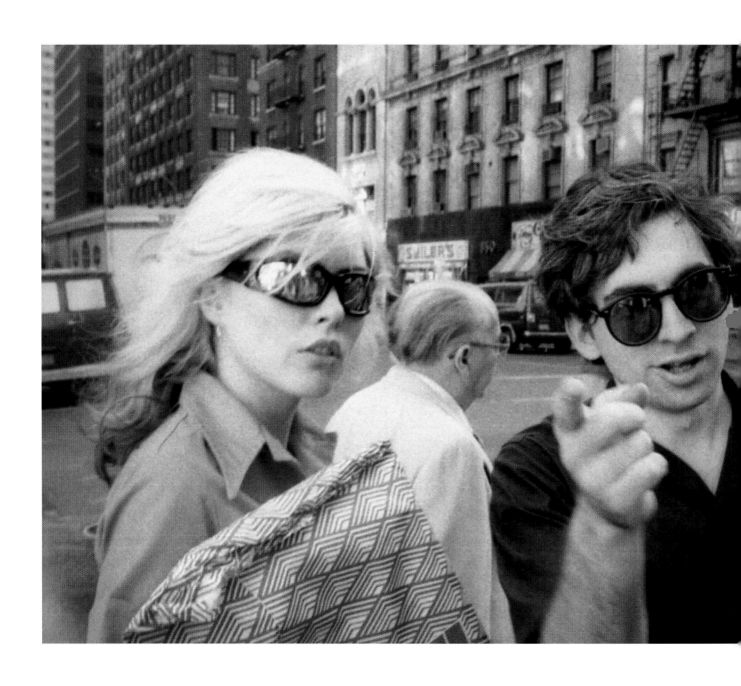

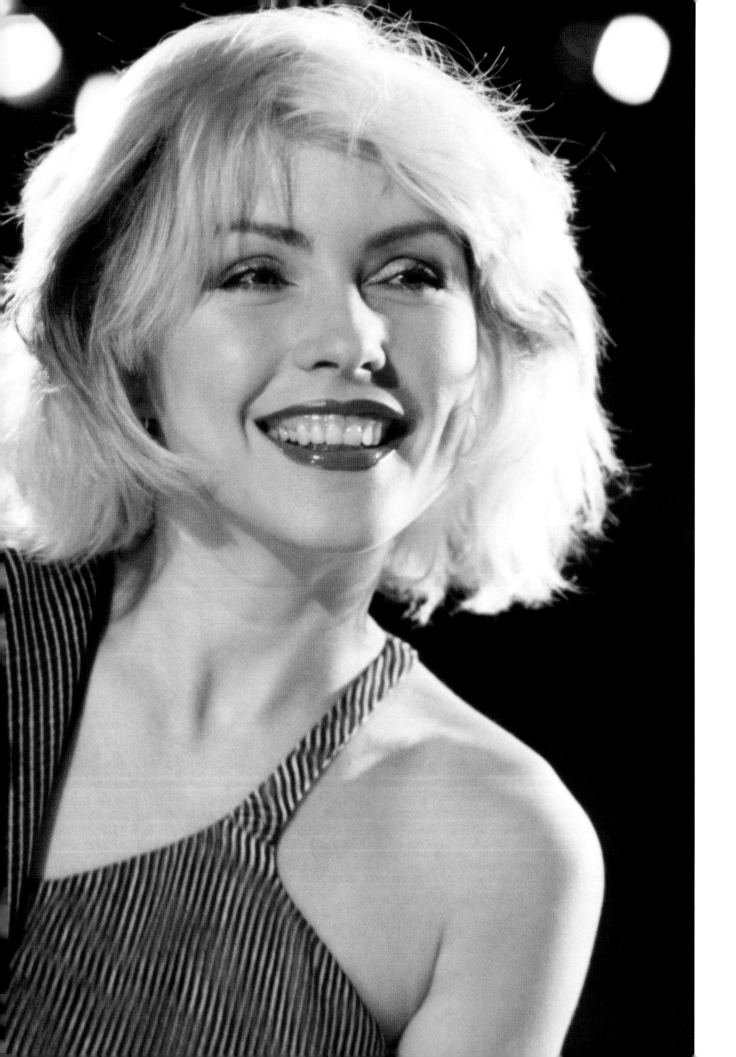

HEART OF GLASS

Blondie continued to tour in Europe and the US, as the third single from the album, a re-mixed 'Heart Of Glass', was finally climbing the US charts. The group made a video with fantastic op-art clothes by Stephen Sprouse, and appeared on various television shows, including *Soap Factory*, a disco show filmed in New Jersey. Although some people on the New York scene thought doing a disco song was a 'sell-out', the group were having fun, living in the moment, and channelling the influence of Kraftwerk. And besides, they'd written the song back in 1975. Their real friends were excited by their success. Eventually, 'Heart Of Glass' went to number one.

After returning from a successful European tour, a frustrated Blondie attempted to renegotiate their deal with Peter Leeds. Ironically, the fact that they were now achieving real monetary success meant it would cost more to 'divorce' Leeds. But there was no choice. Leeds was out, no matter how much they had to pay. Eventually, they decided to work with Shep Gordon, Alice Cooper's manager, whom they'd met while supporting Alice at the Philadelphia Spectrum. Once Leeds was out, I no longer worked for the band – except informally.

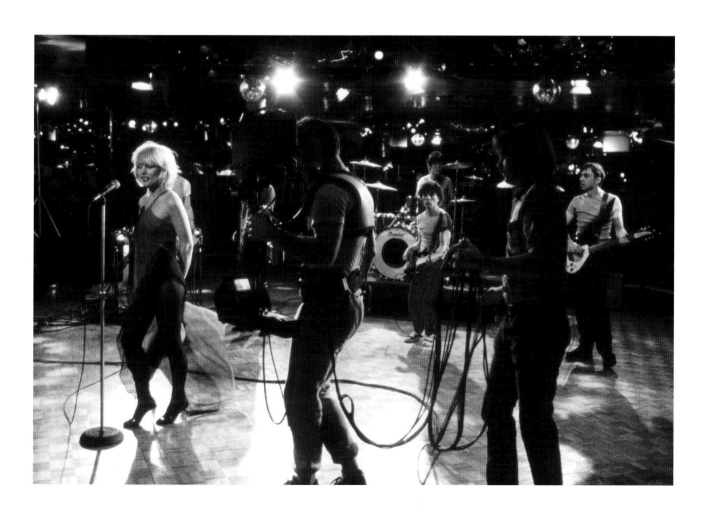

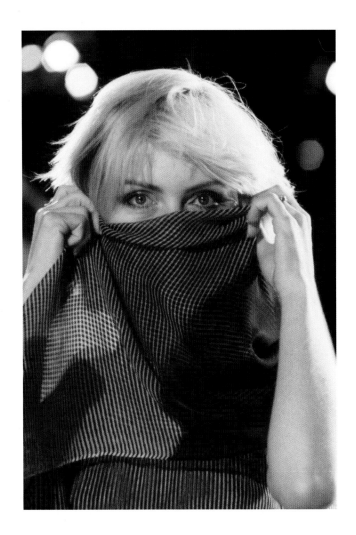
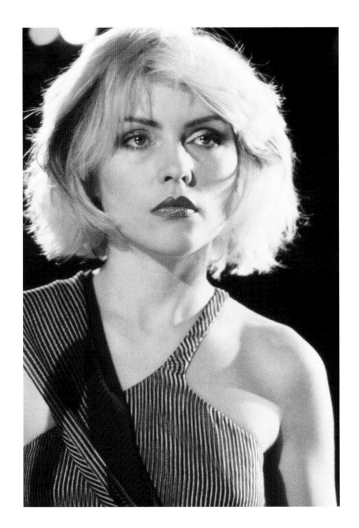

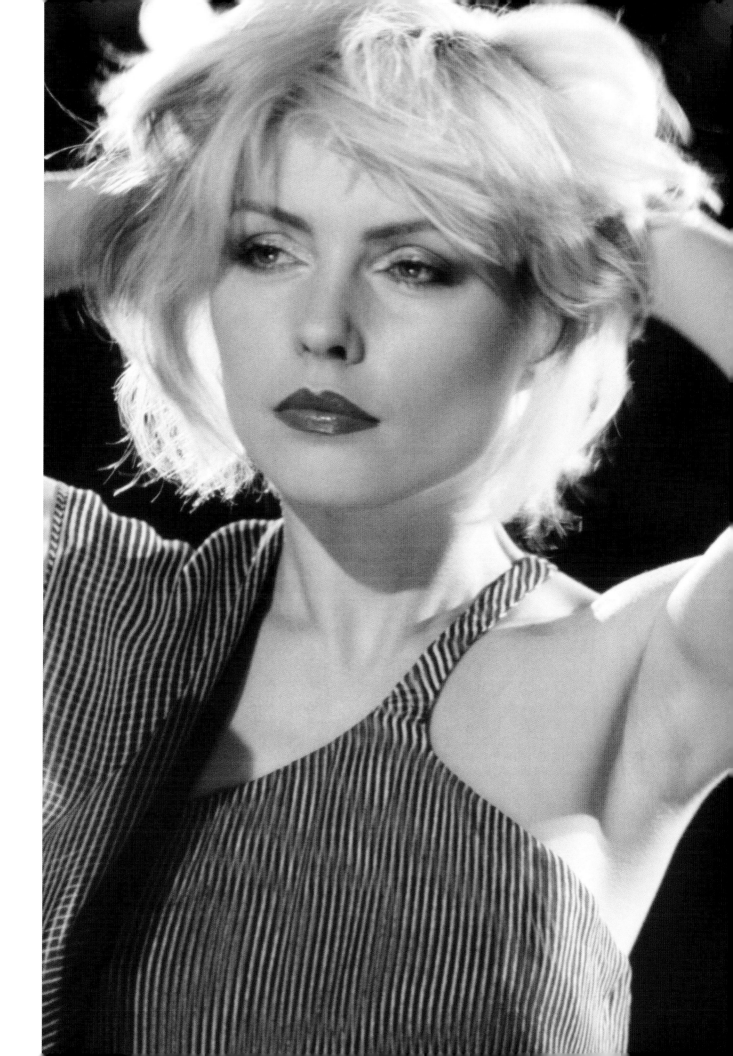

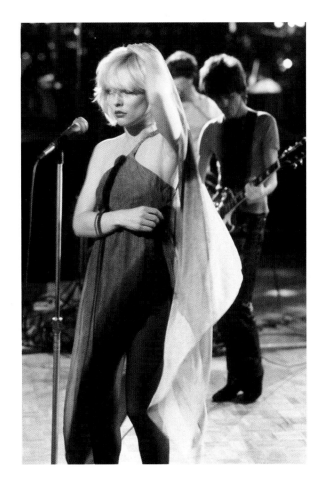
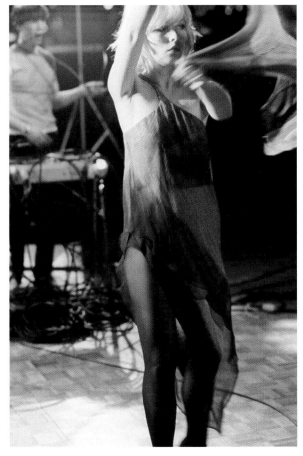

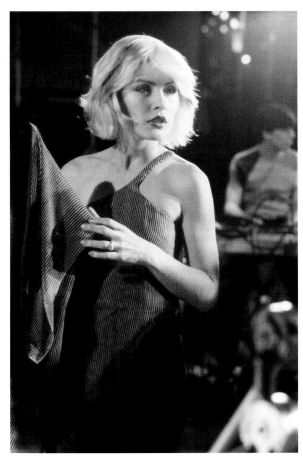

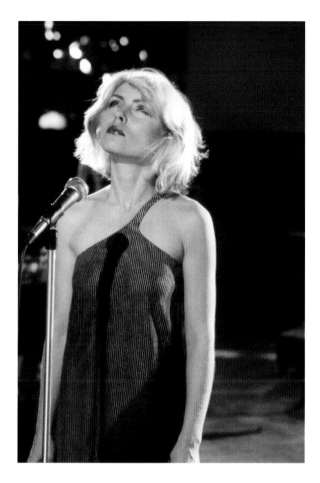
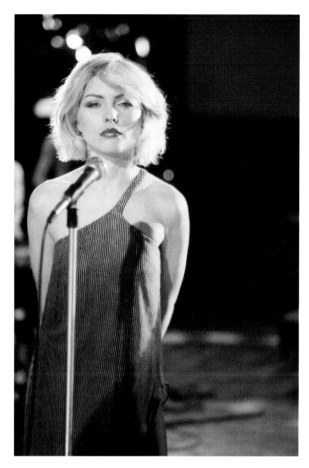
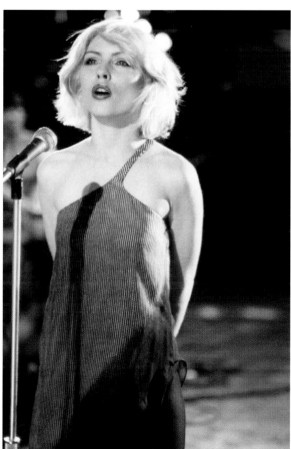
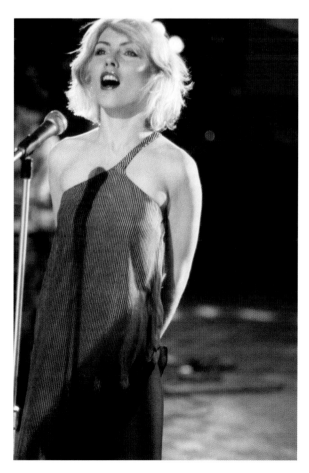

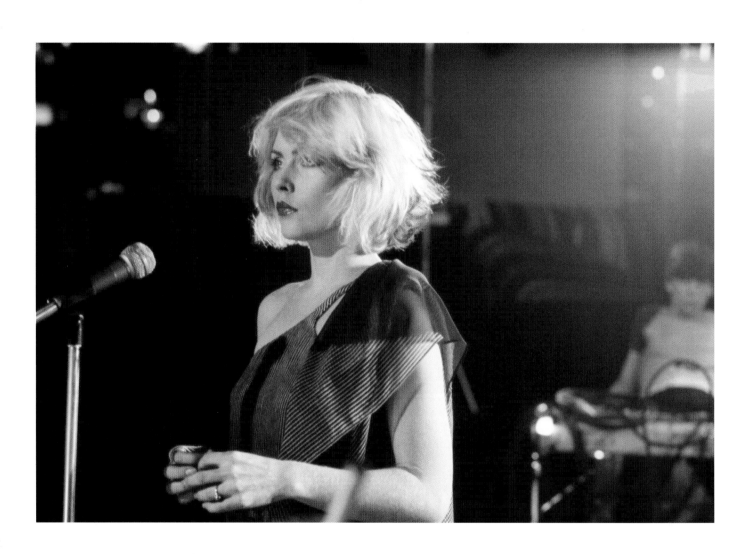

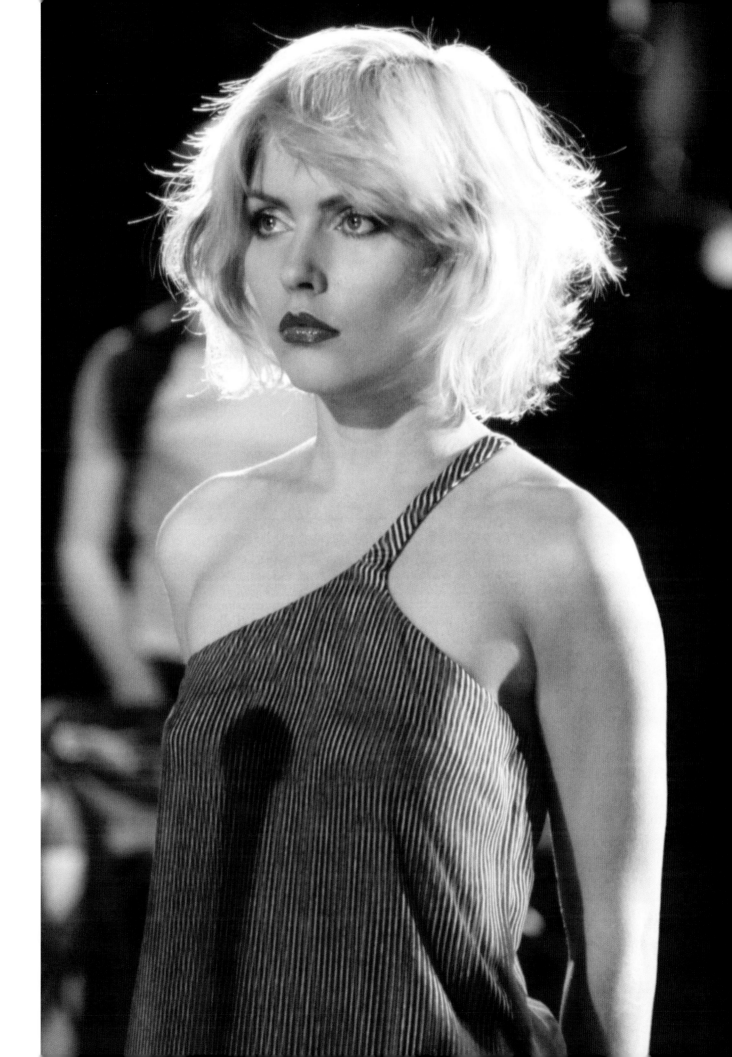

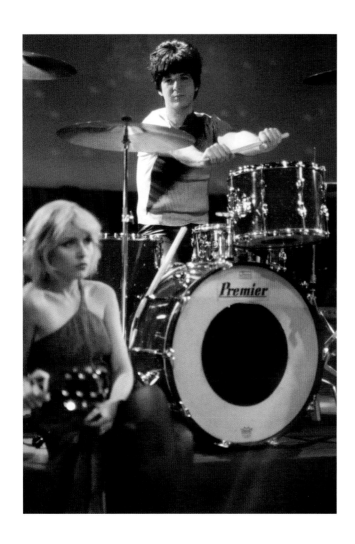
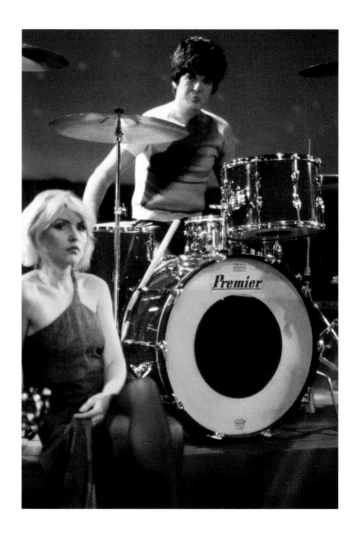

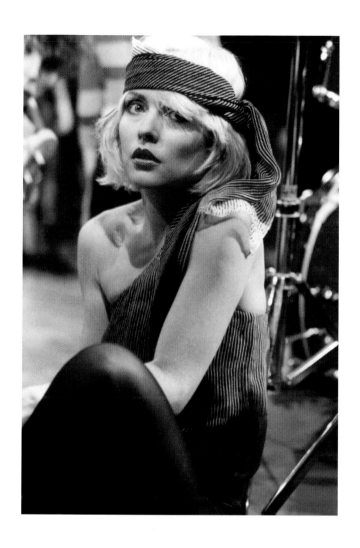
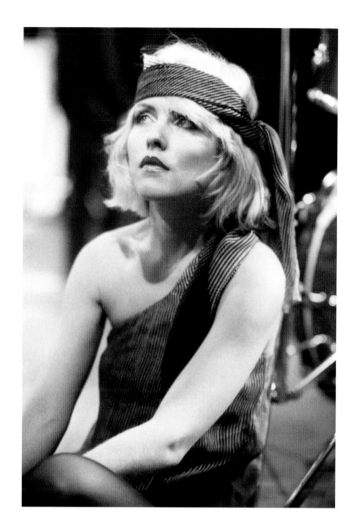

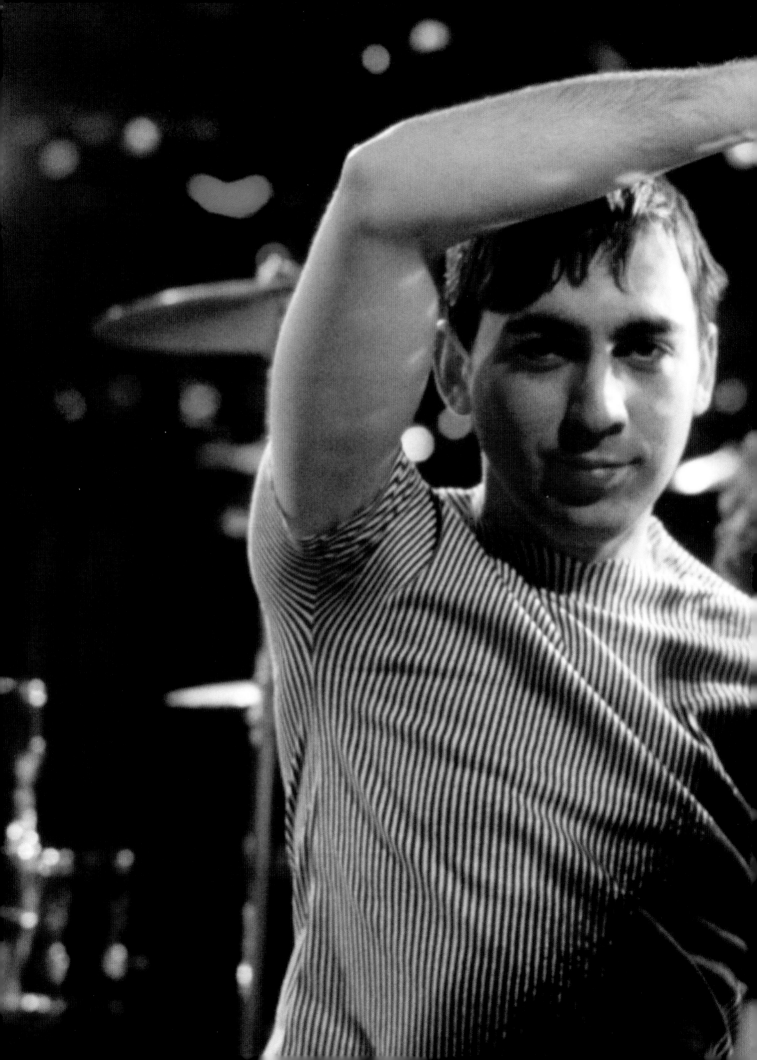

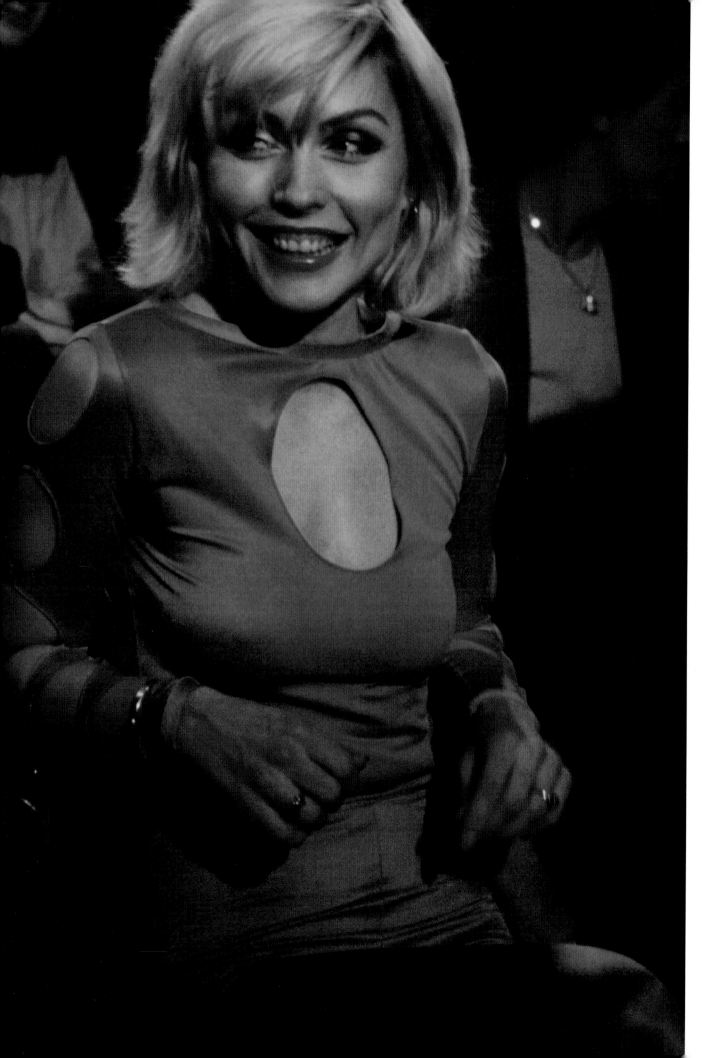

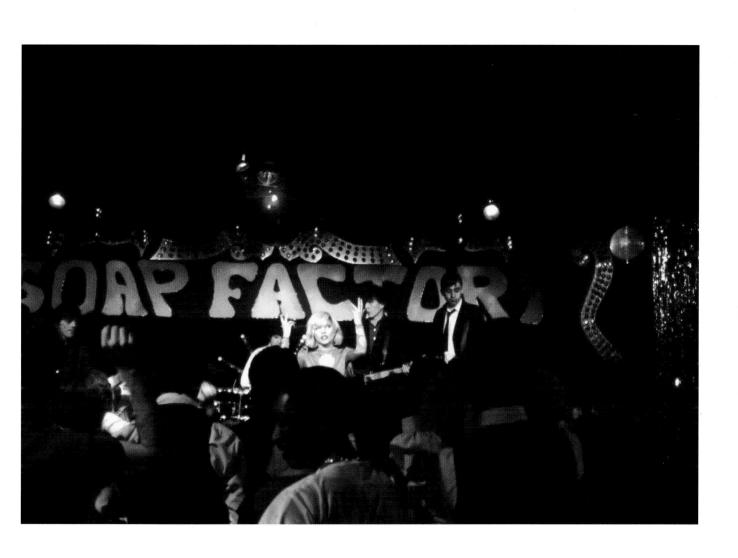

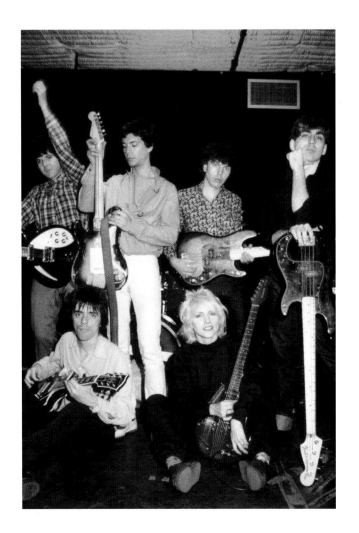
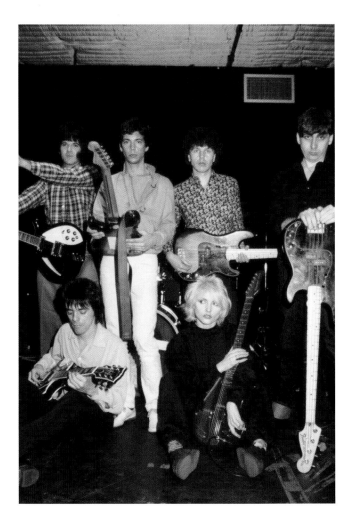

At SIR Studios, Blondie pose for the cover of
Trouser Press *magazine before continuing*
rehearsals for the upcoming US tour.

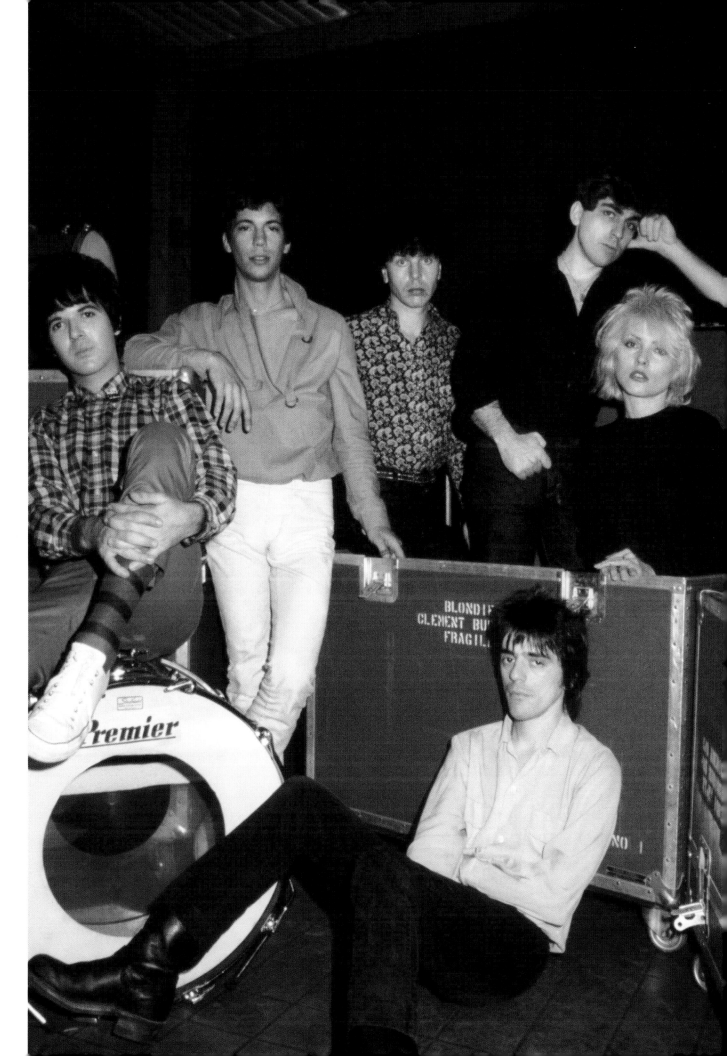

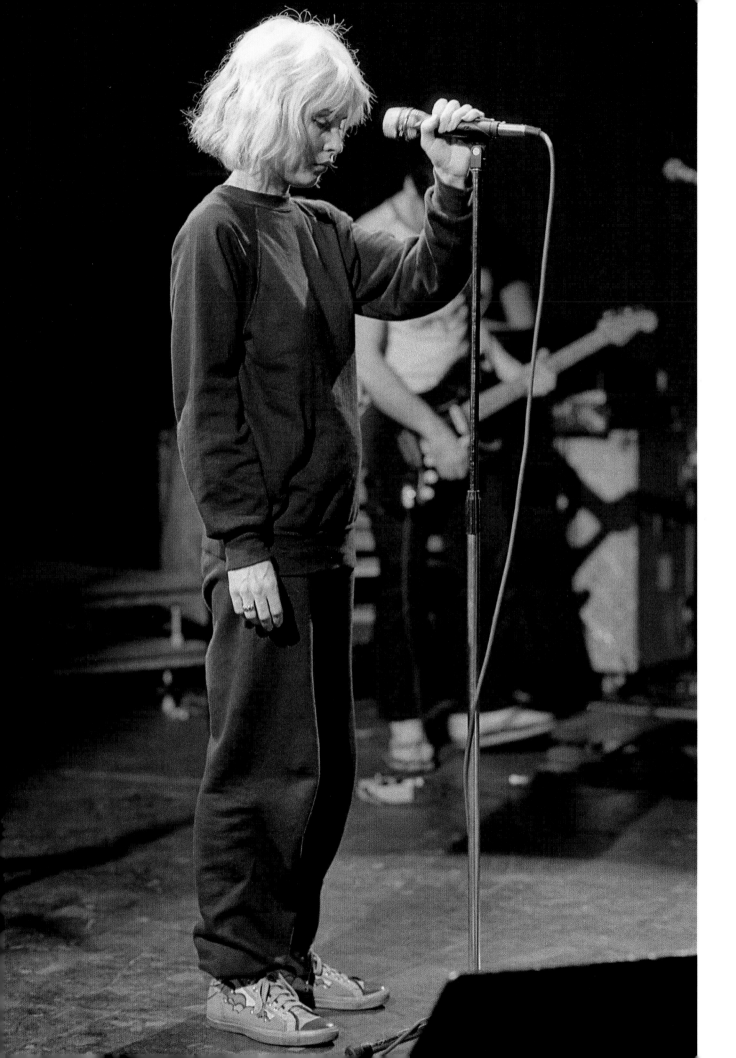

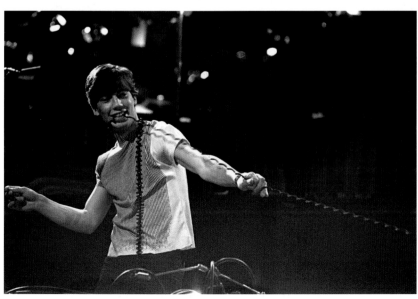

Rehearsals before the American tour.

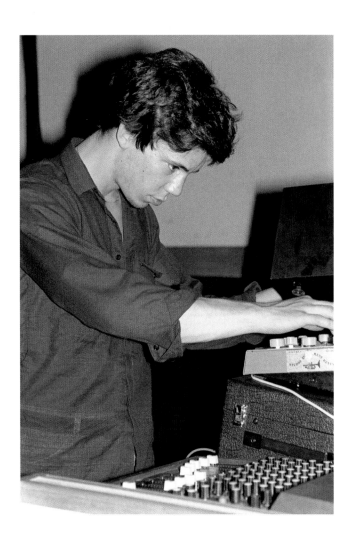

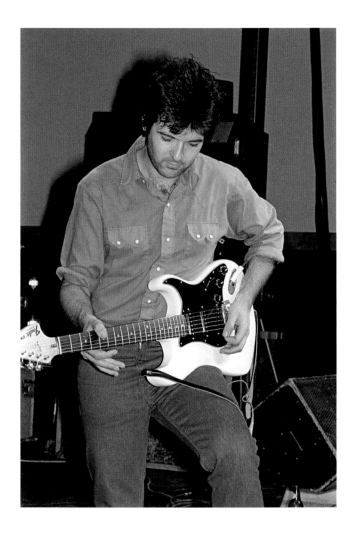

Left: *Jimmy Destri.*
Right: *Clem Burke.*

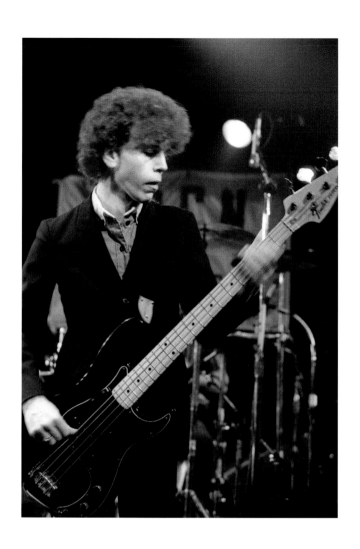

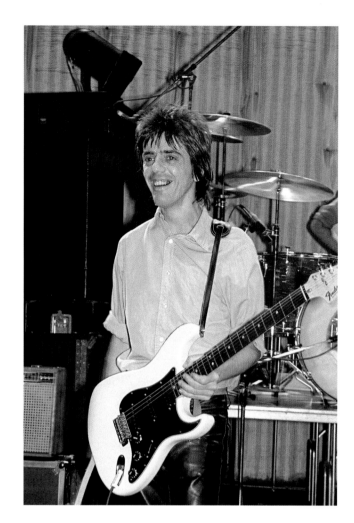

Left: Nigel Harrison.
Right: Frank Infante.

U.S. TOUR
SUMMER 1979

In the summer of 1979, Blondie embarked on a tour of the United States. A German magazine hired me to take photographs provided they could get an interview with Debbie, and she agreed. I joined them in New Orleans, halfway though the tour. Their support act was a British band called Rockpile, consisting of Nick Lowe, Dave Edmunds, Terry Williams and Billy Bremner. I was very friendly with the band members and their volatile manager, Jake Riviera, one of the founders of Stiff Records, who also managed Elvis Costello.

Blondie were now used to playing on big stages, and had learned how to 'fill up' a stage from working with Debbie's long-time friend, Tony Ingrassia, who'd directed the Andy Warhol stage show *Pork*. Debbie took costume guidance from Stephen Sprouse, who believed that a monochrome look was modern and kept the audience from being too distracted by the clothes.

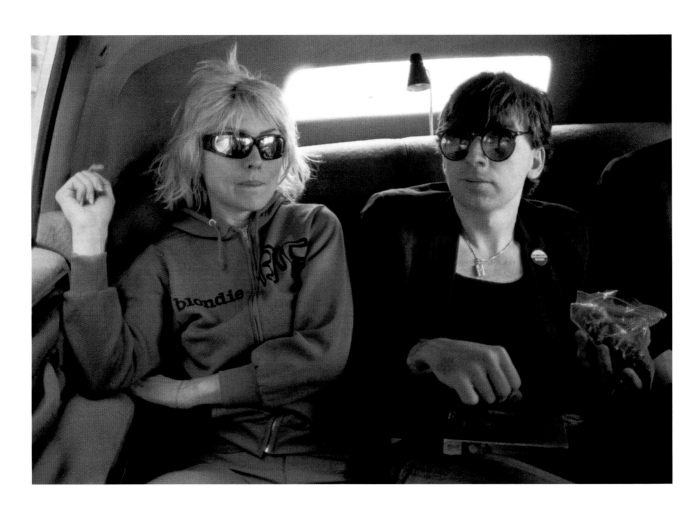

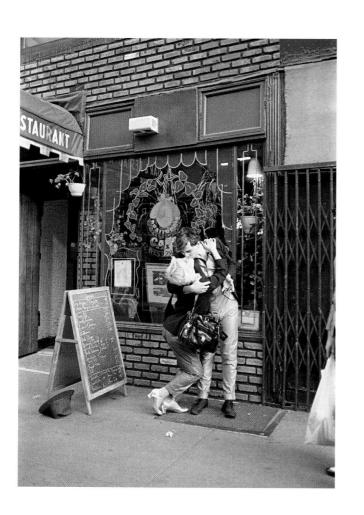

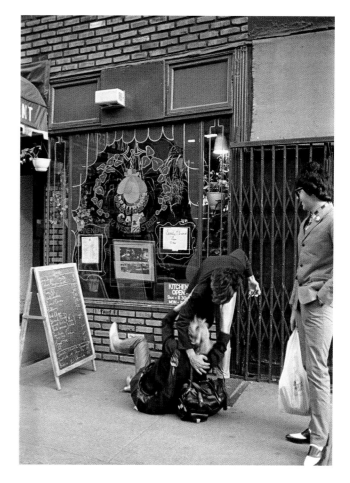

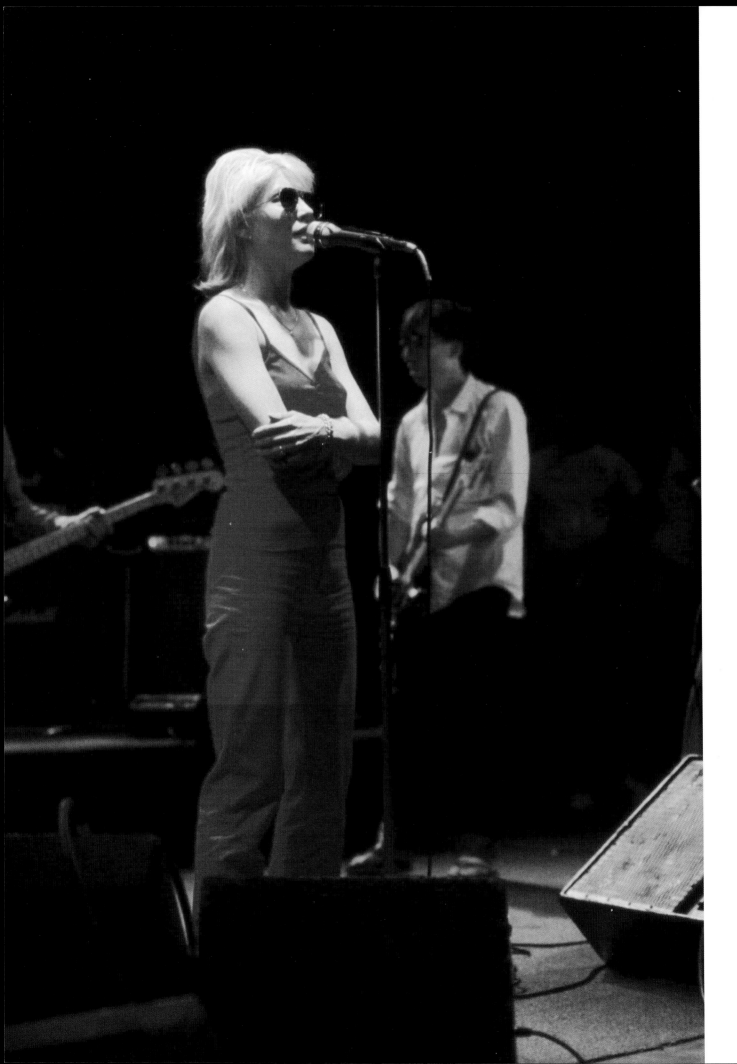

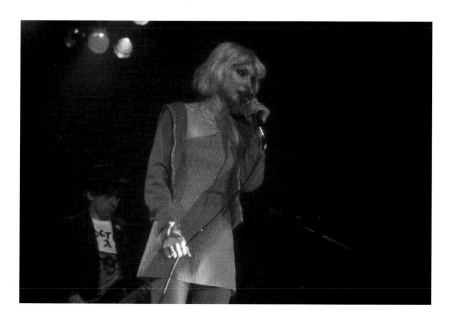

ASBURY PARK
NEW JERSEY

At the Asbury Park show at the beginning of the tour, Debbie wore a Sprouse one-shoulder op-art mini-dress in yellow and red with the Blondie tour hoodie, which came off after a couple of songs. For each of the other shows I attended, she wore a solid mini-culotte dress with matching tights – black in New Orleans, navy blue in Denver, and white for the show at the Aladdin Casino in Las Vegas, always with medium heel Capezio dance shoes with straps. Usually she would enter wearing a jacket, but it would come off after a song or two to facilitate her energetic moves.

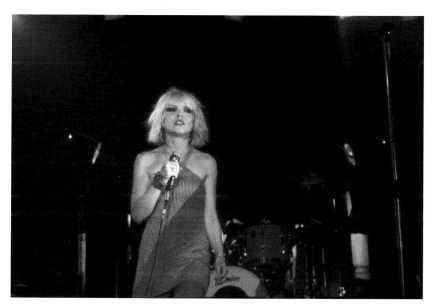

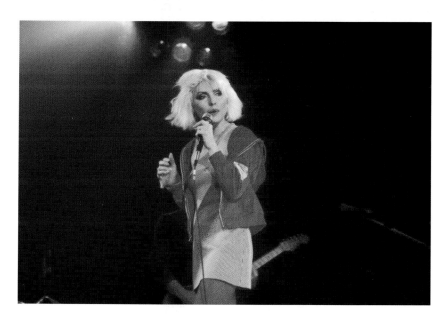

Left: *The band soundchecked early, and then Debbie changed into her Stephen Sprouse dress for the sold-out show.*

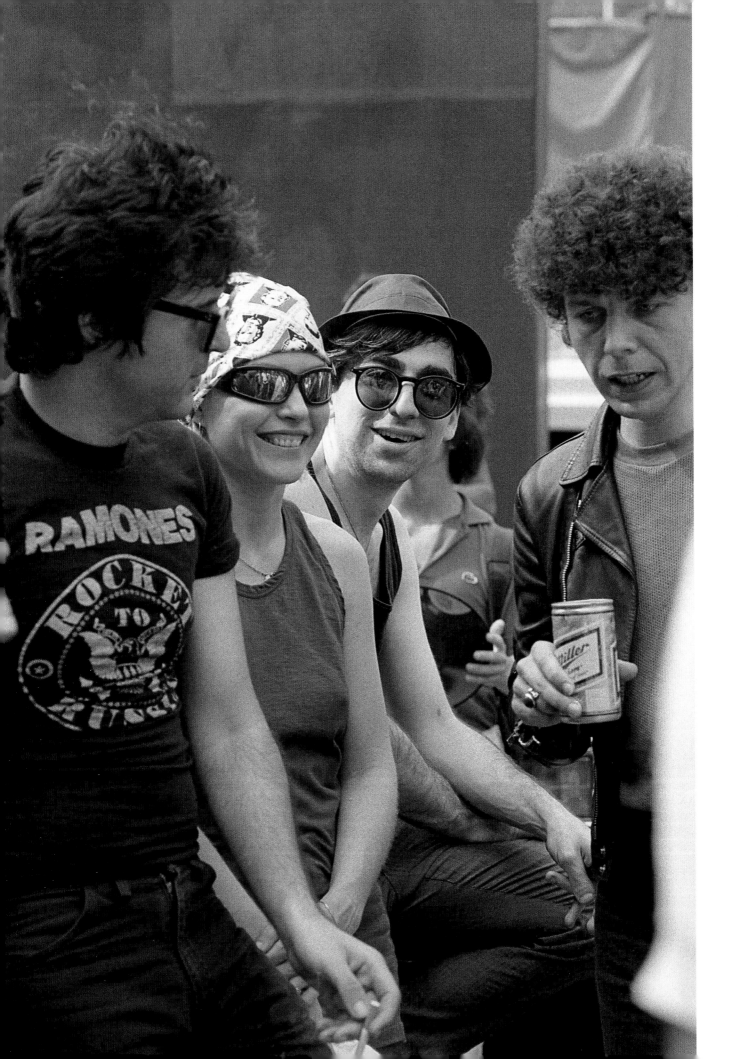

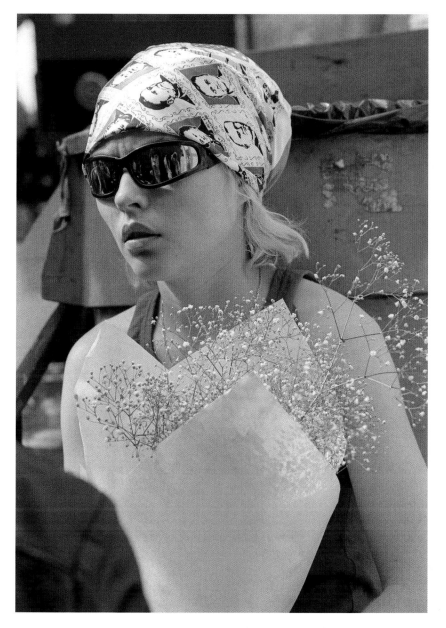

CENTRAL PARK
NEW YORK

The whole tour was very stressful, especially for Debbie and Chris, who just didn't like touring, period. Outsiders think touring is glamorous and exciting, but in reality it's often just 23 hours of boredom, with one hour of the pleasure of performing – pleasurable, that is, *if* the sound is good, *if* the audience responds with enthusiasm, *if* you're not thinking of strangling the guitar player, *if* the air conditioning hasn't wrecked your voice.

You can enjoy yourself on the road – *if* you have a good book to read, *if* the girl you picked up last night didn't have VD, *if* you don't get insomnia, *if* the drug you bought from a roadie is coke and not speed. Sometimes you have a friend in the city you're playing, and they have a car and pick you up and drive you around, but other than that you're just stuck. You don't get to sleep until 3 a.m. (if you're lucky), and so by the time you wake up and have breakfast, you're already thinking about the 4 p.m. soundcheck. Then maybe you go back to the hotel, and have two hours till you have to leave for the gig. And so it goes.

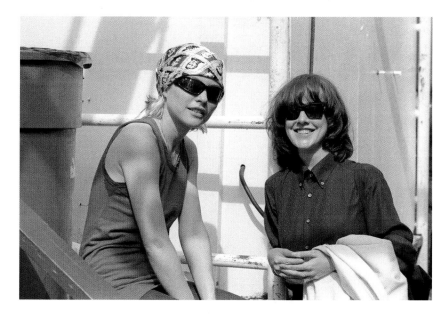

Left: *Blondie did a huge outdoor show in New York's Central Park, their first big show in New York since 'Heart Of Glass' went to number one. Legendary photographer David Gahr snapped a photo of Debbie and I together.*

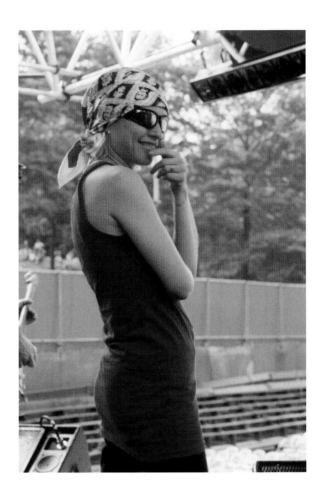

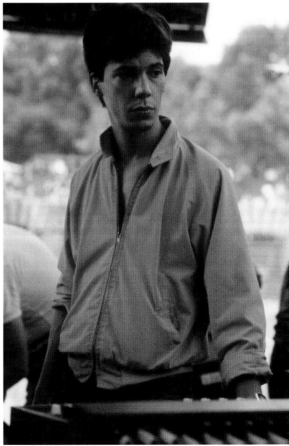

Right: These photos are from the
soundcheck for the open-air concert.
Following pages: You can see me sitting under
Jimmy Destri's keyboard. The show later that
evening was an unqualified success.

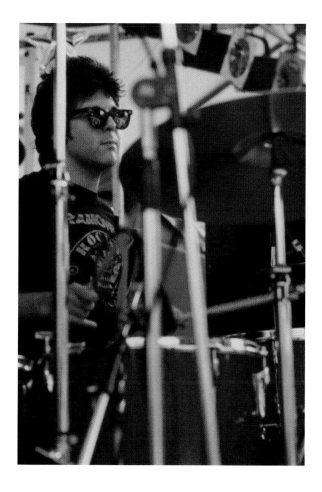

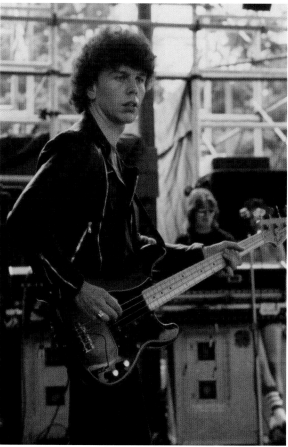

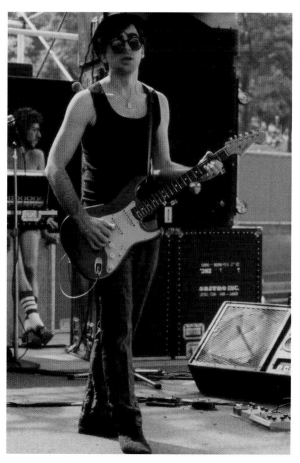

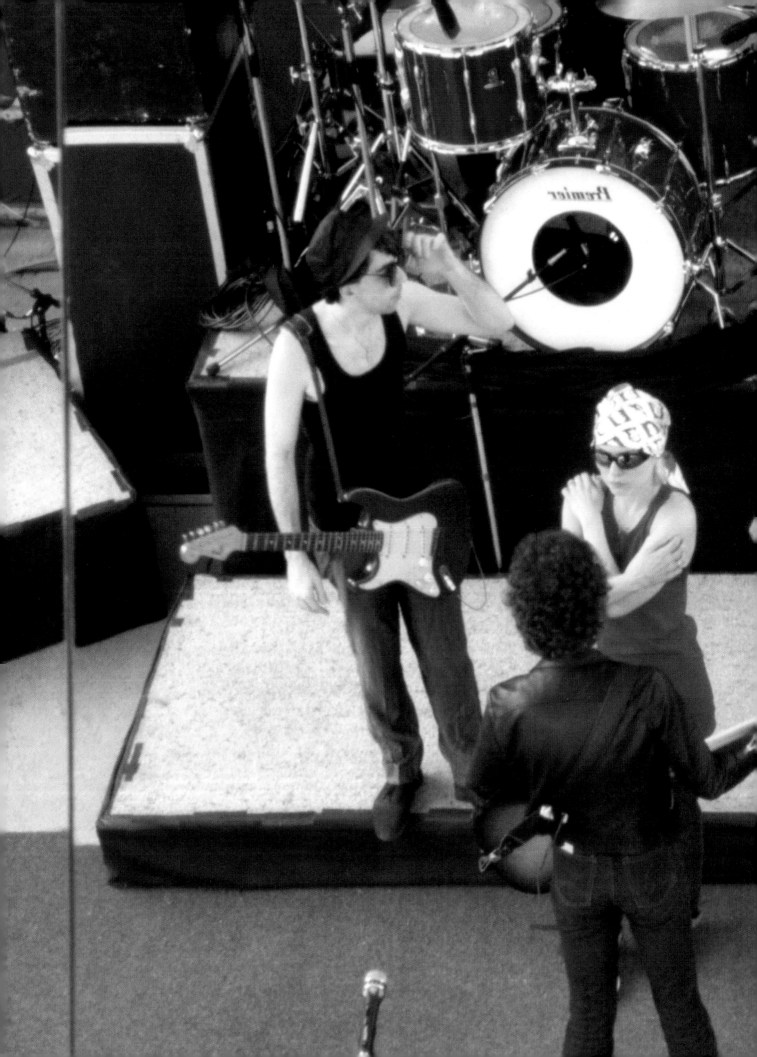

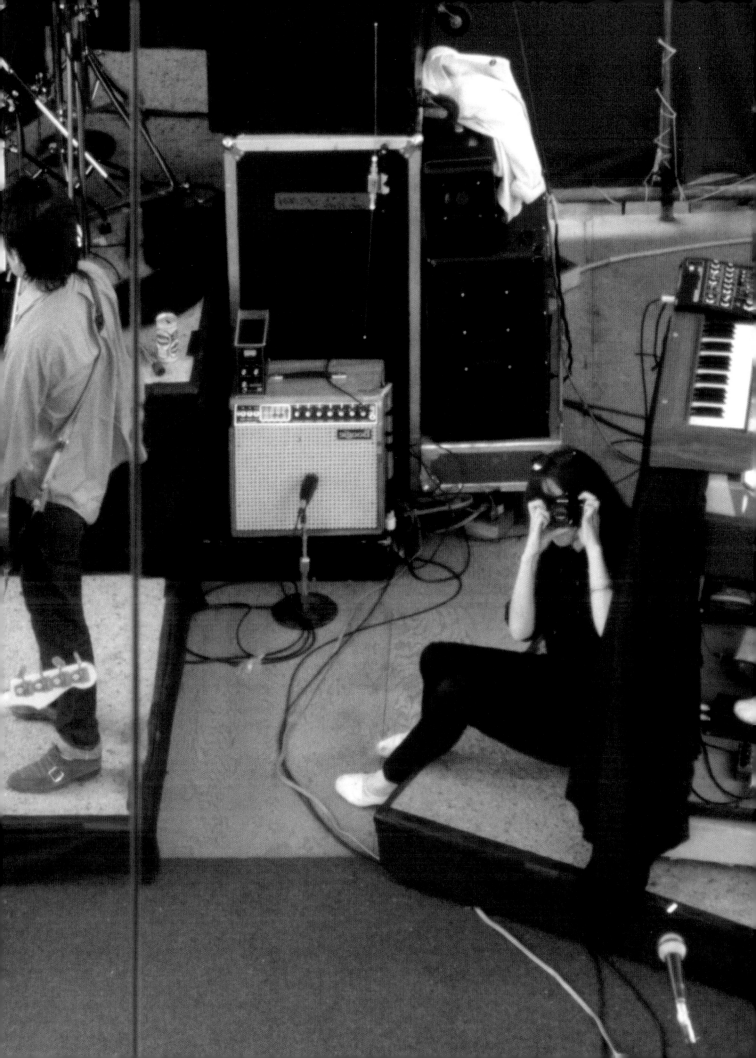

NEW ORLEANS
LOUISIANA

New Orleans was the only place we had any time to look around. It was a beautiful city, and Debbie was great, spending the better part of a day walking around with me before the soundcheck. We looked at some thrift shops, and tried to get breakfast at the famous restaurant Antoine's. They turned us away for inappropriate attire, sending us to a cafe down the street. After we'd ordered, we noticed that all the waitresses were kind of butch, wearing 'Keep on Truckin" T-shirts, and all the customers were women. Antoine's had sent us to what appeared to be a lesbian restaurant!

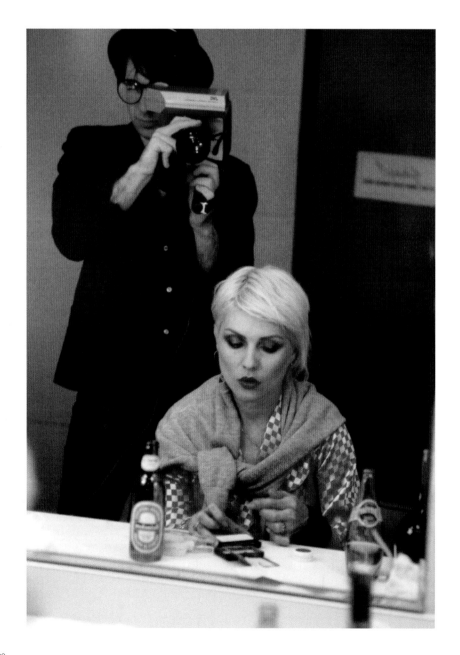

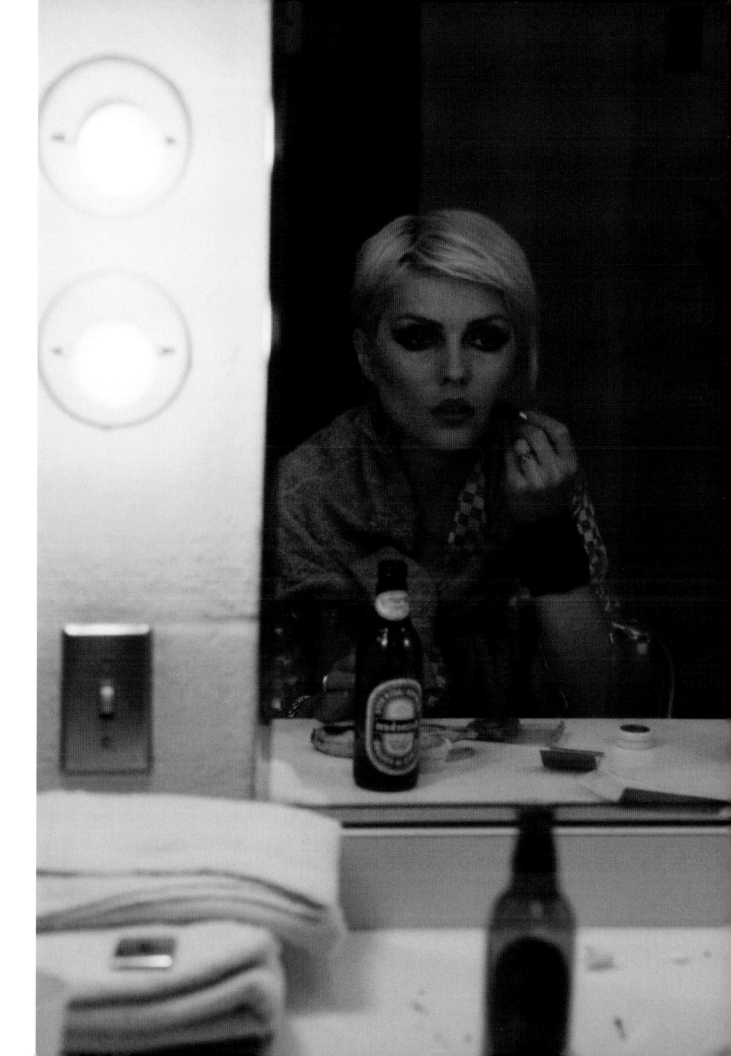

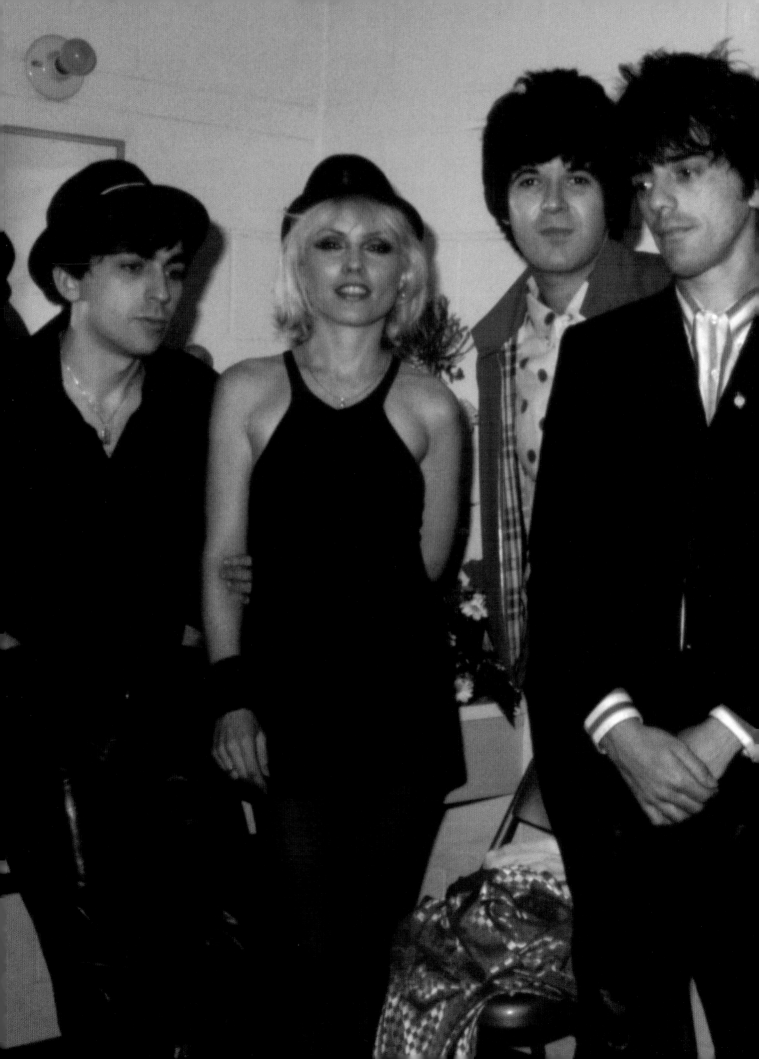

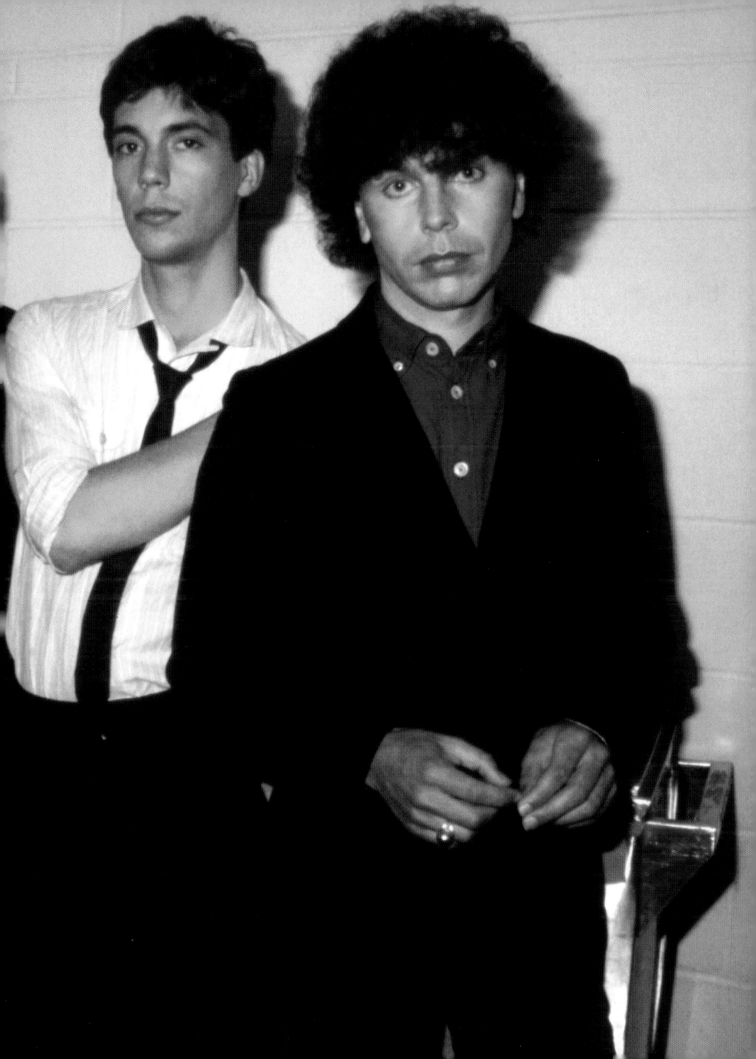

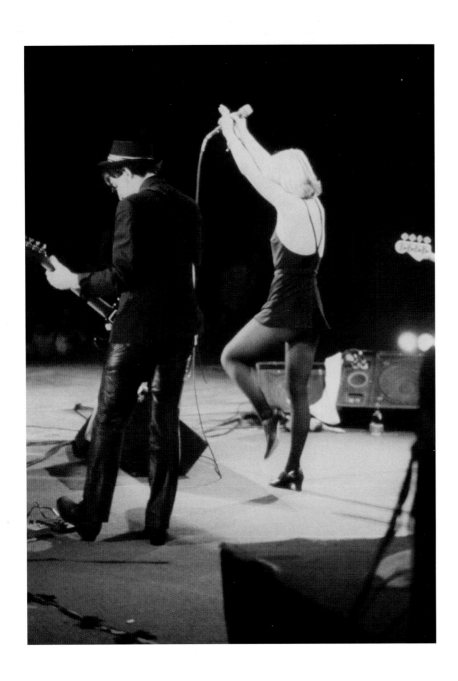

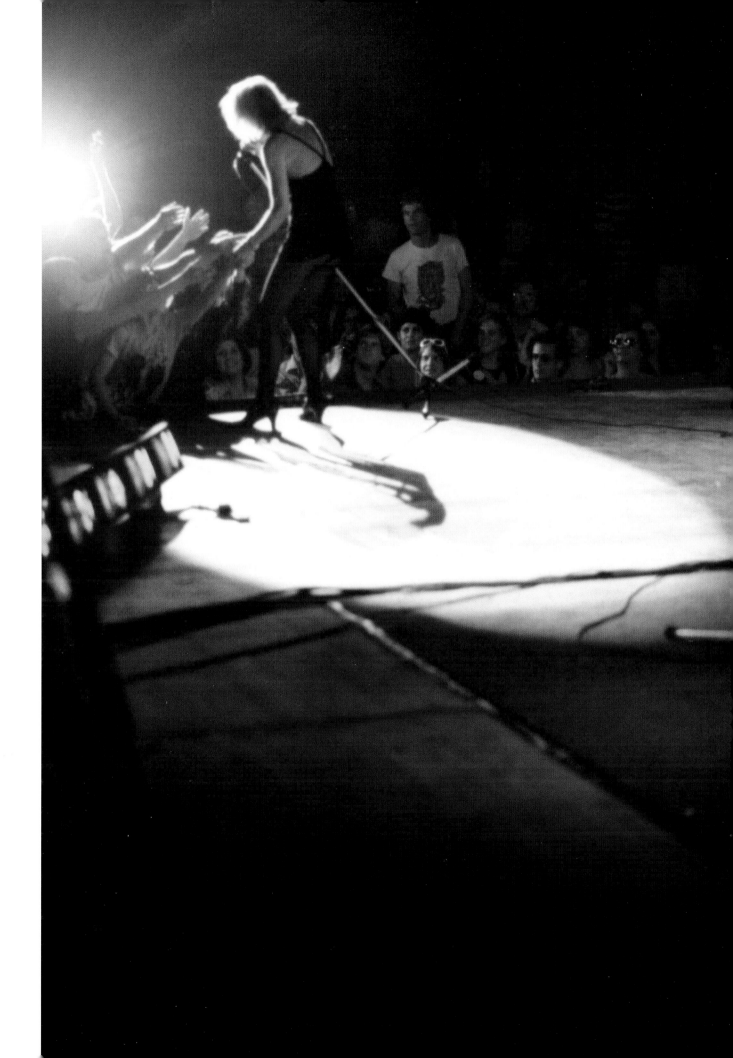

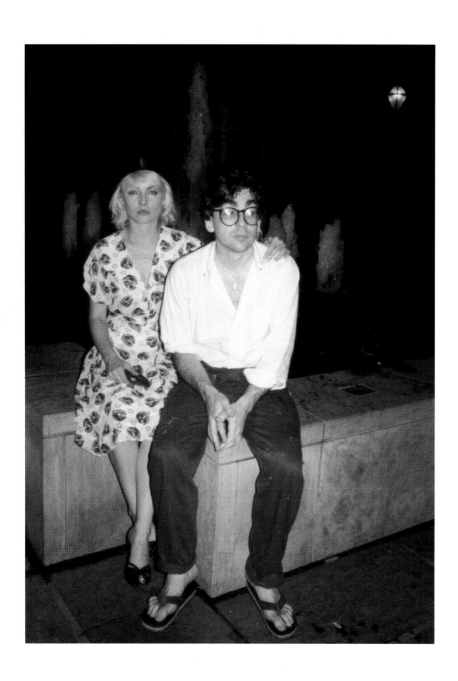

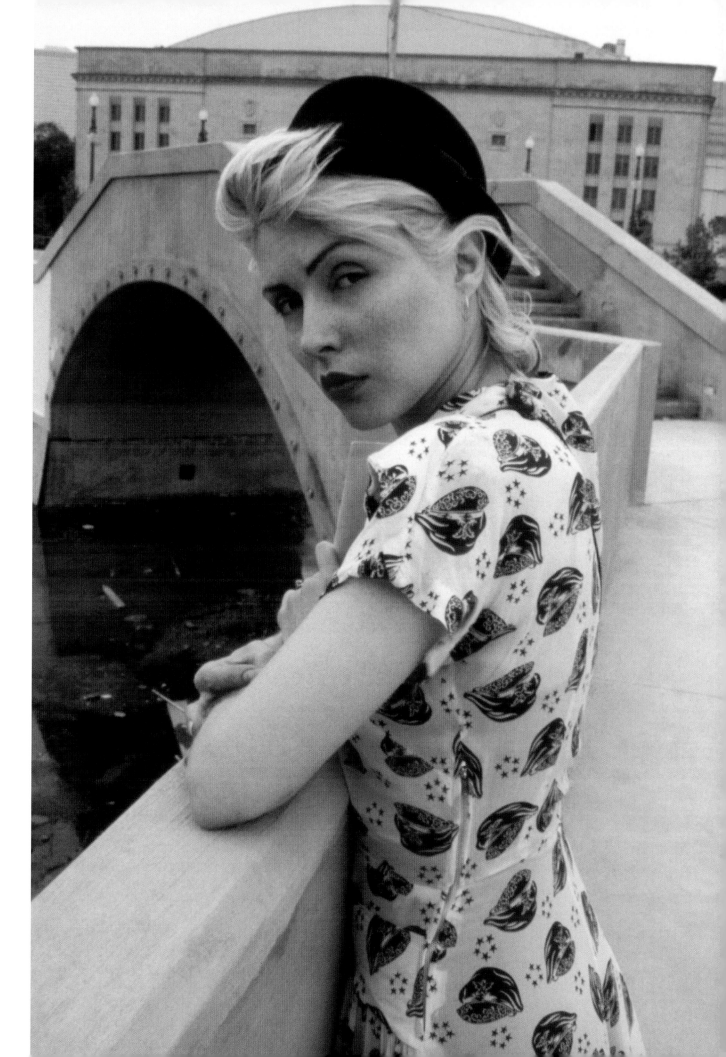

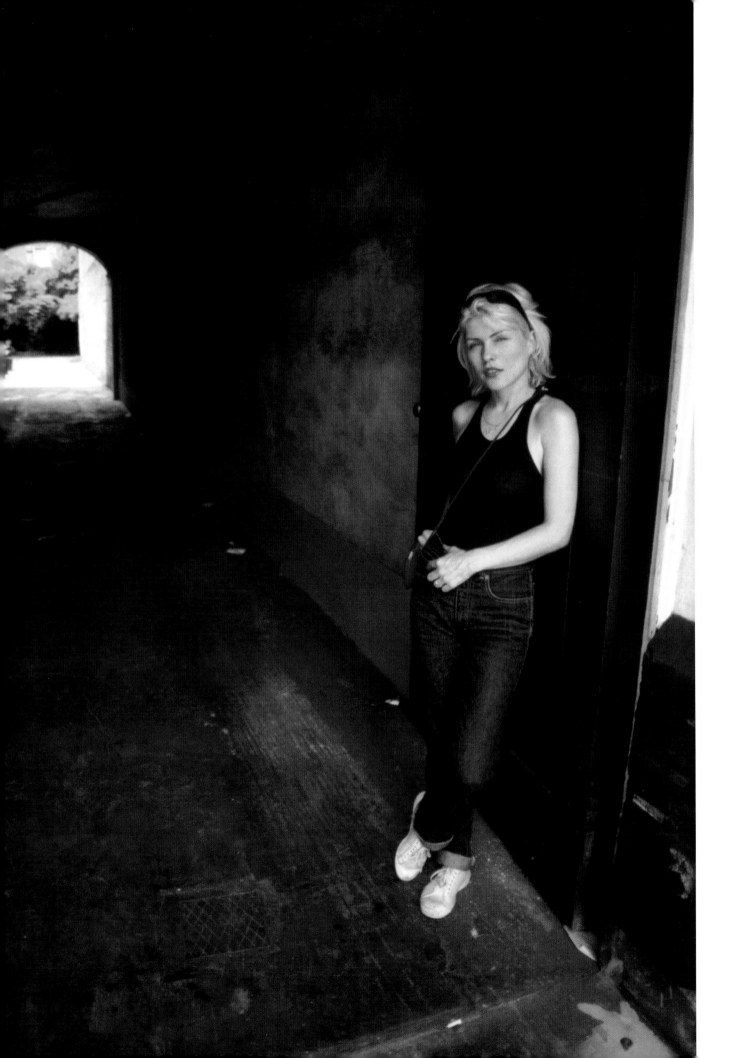

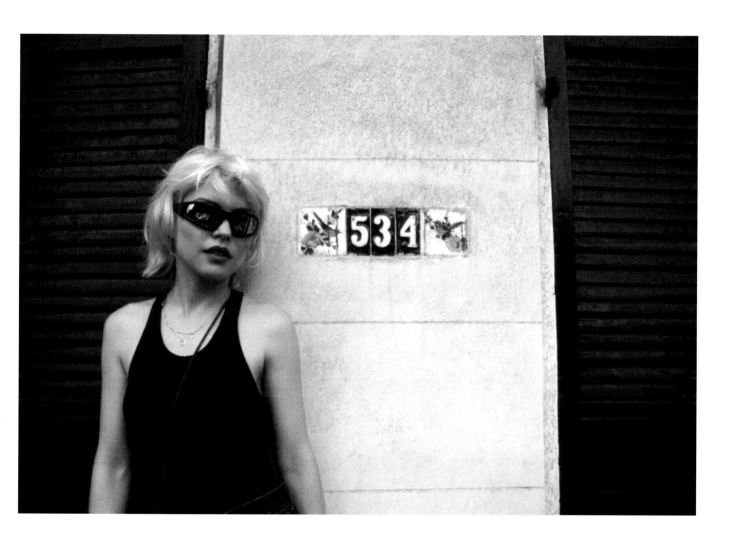

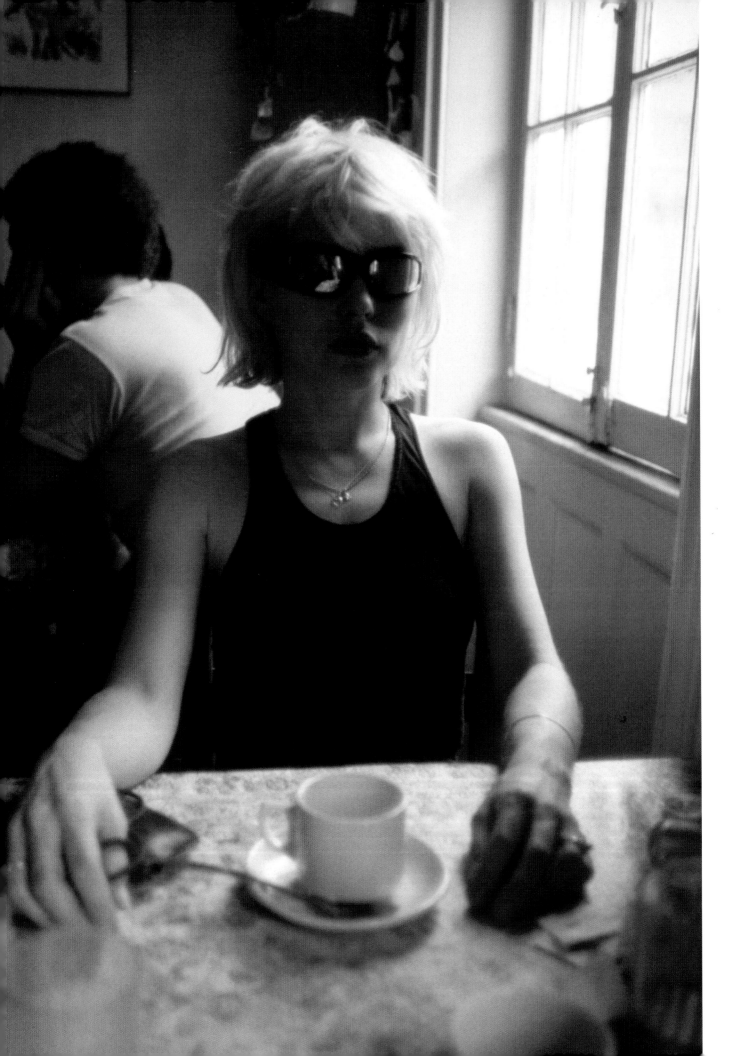

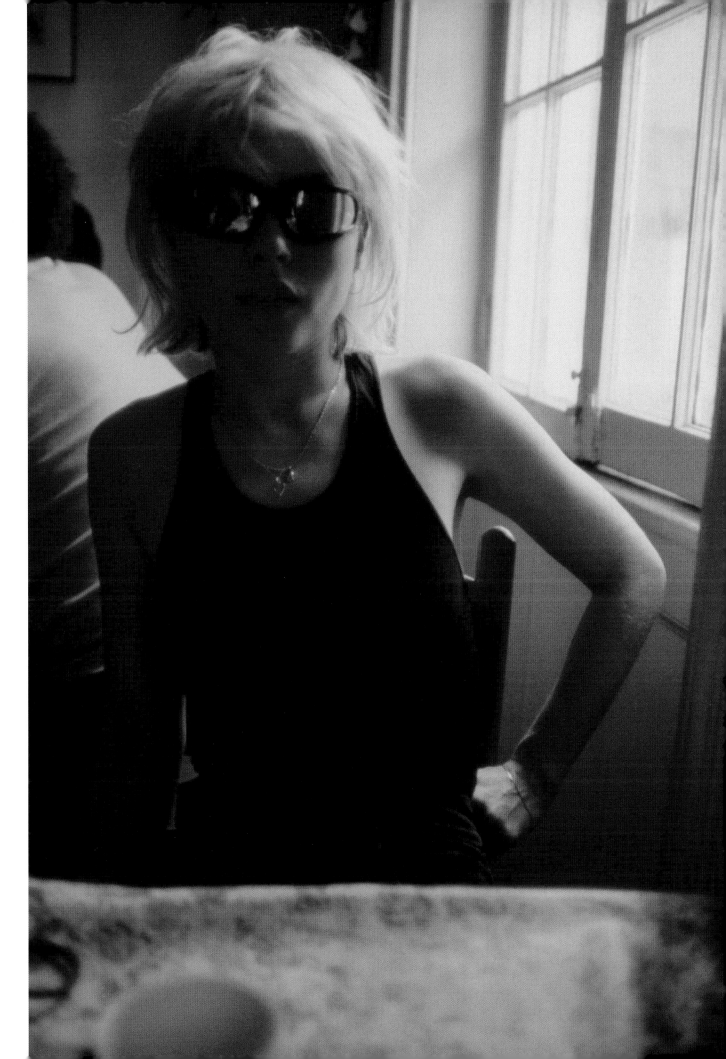

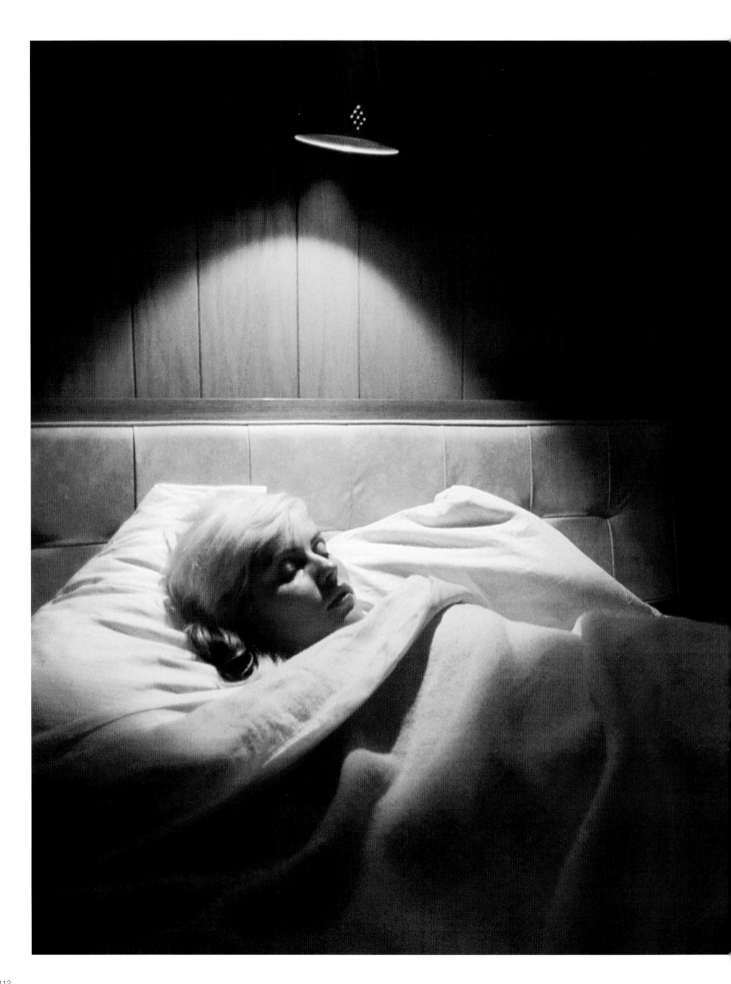

After the show. In their hotel room, a sleepytime Goldilocks drifts off to the land of nod while Chris contemplates eternity.

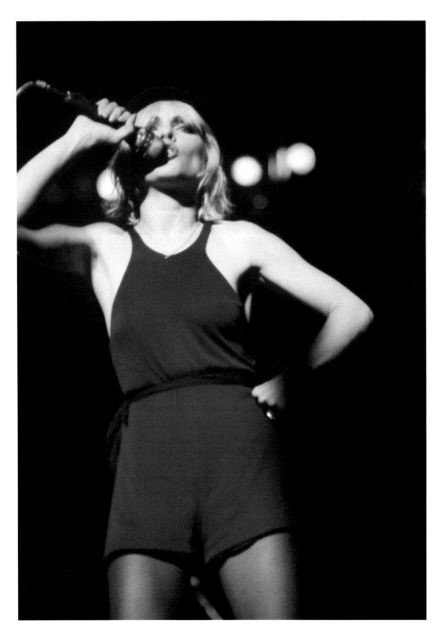

Left: In Denver, Debbie wore midnight blue and seemed to be channelling the spirit of Marlene Dietrich in The Blue Angel.
Right: After the show, an old friend came backstage with her baby and Debbie was as gracious as always. She has always stayed connected to people in her past.

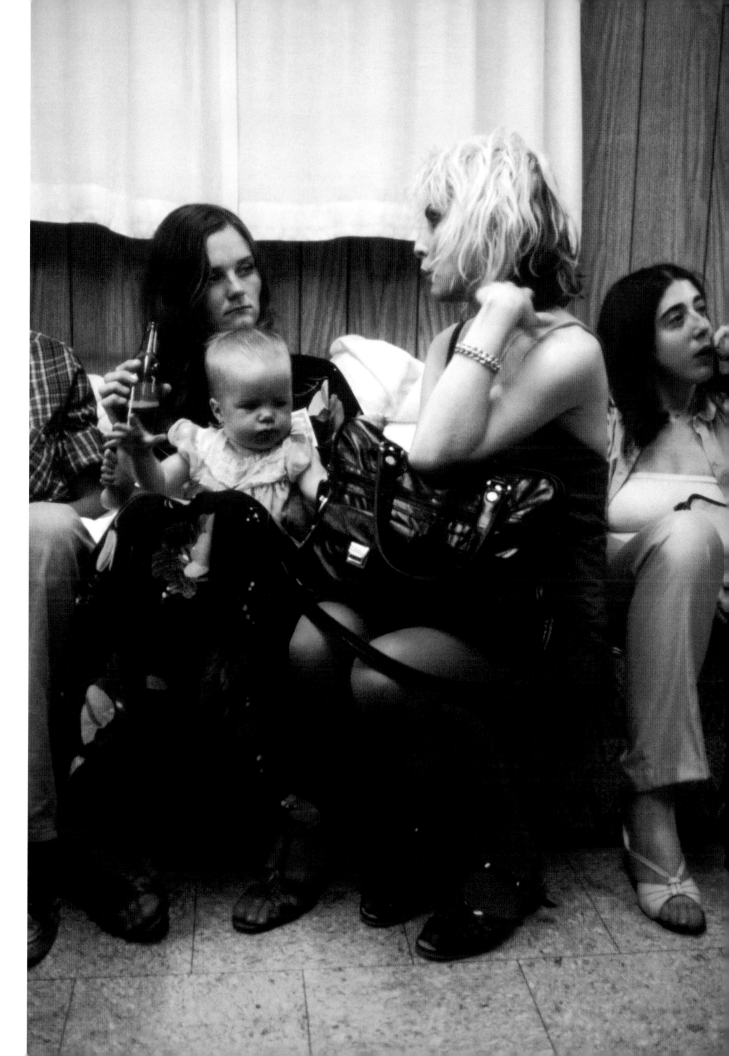

Debbie visits Nick Lowe and Dave Edmunds backstage after Rockpile's New York show at the Palladium.

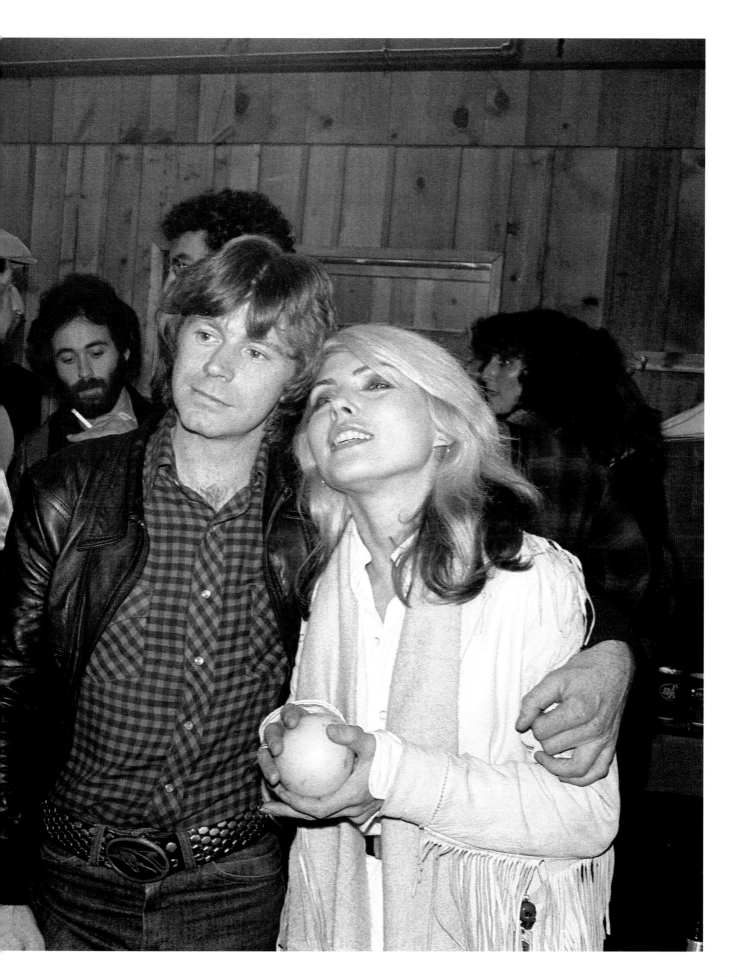

LAS VEGAS
NEVADA

Arriving at Las Vegas airport, everyone was excited. There were also lots of excited fans, following the band through the lobby to the theatre before the show.

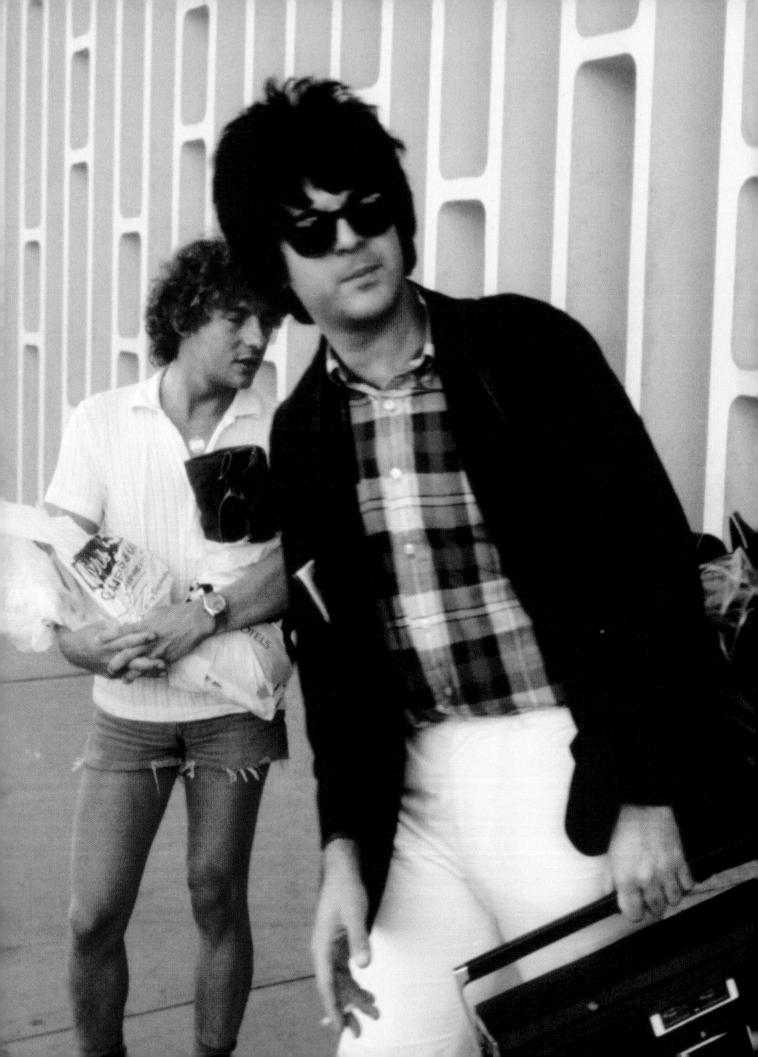

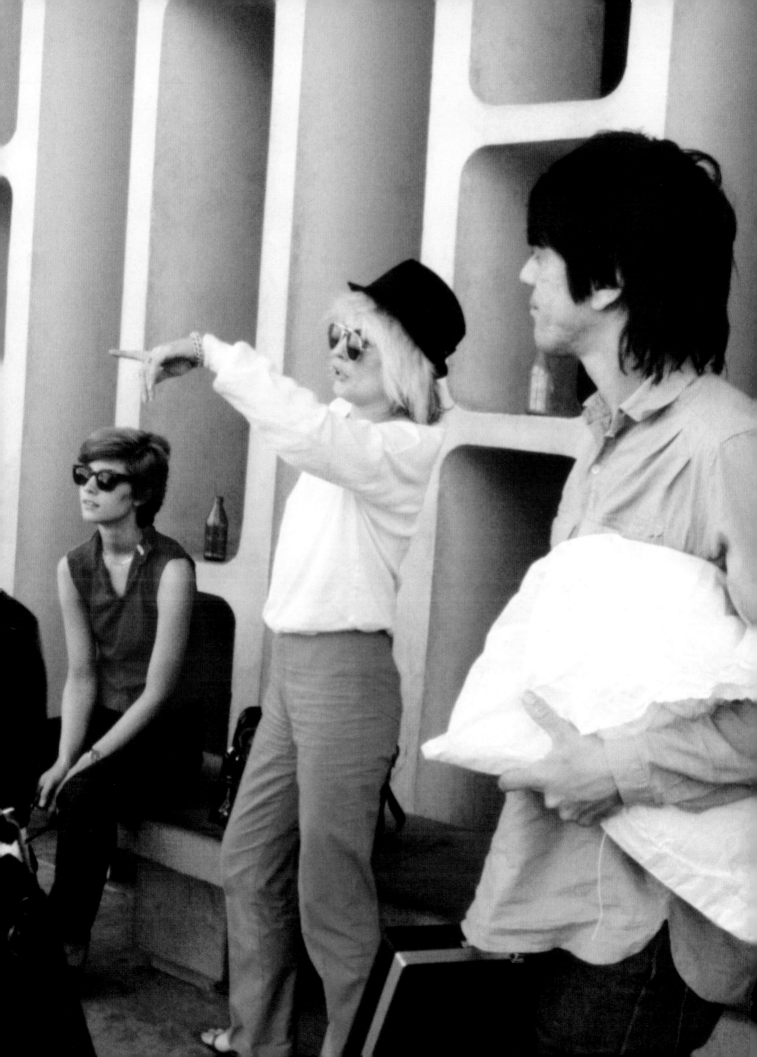

Onstage, Debbie made a dramatic entrance, wearing a beautiful sequinned scarf over the white dress. I always thought it was a tribute to Elvis Presley, who had married Priscilla at the Aladdin and performed there many times. The show was one of their best and most energetic. Fans presented Debbie with roses on stage. After the show Debbie collapsed on the sofa, her soaking wet hair wrapped in a towel. I always thought she looked like a figure in a Renaissance painting.

I stayed on tour until Oakland, across the bay from San Francisco. Things had got strained between Blondie and Rockpile, due to the aggressive, competitive nature of Jake Riviera. There was a big blow-up in Denver and Rockpile weren't at the show in Las Vegas, where Badfinger opened for Blondie. I was seen as being in the Rockpile camp since we were good friends, and I'd been travelling on their bus to save money on airfare. At the Oakland show, Jake convinced promoter Bill Graham to let Rockpile do four encores – unheard of, for an opening band. Both Nick Lowe and Dave Edmunds had a strong fan base in the Bay Area, and both had current solo records. Their fans gave them a warm welcome, but to let them do four encores was a diss to Blondie. Also, some of the Rockpile fans didn't think Blondie were 'cool' (the disco curse), so they left after Rockpile's set. It was an uncomfortable situation all around.

After the show, Blondie's exemplary tour manager, Bruce Patron, told me Blondie would no longer pay for my hotels, so I got a ride with Rockpile to the Howard Johnson's in Mill Valley. The next day, my friend Des Brown drove me to my mom's house in Forest Knolls. Both bands continued on to Los Angeles.

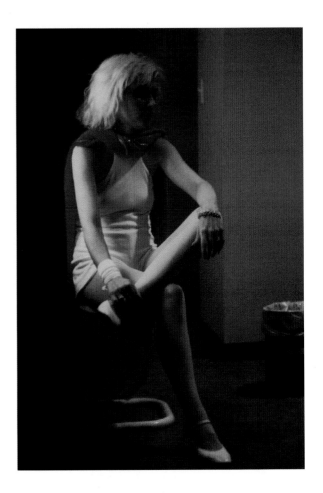

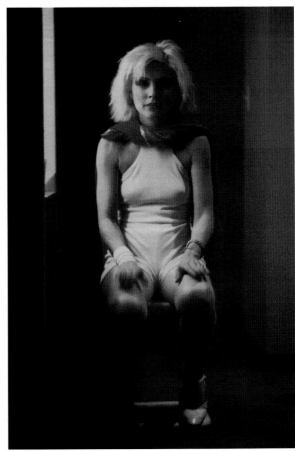

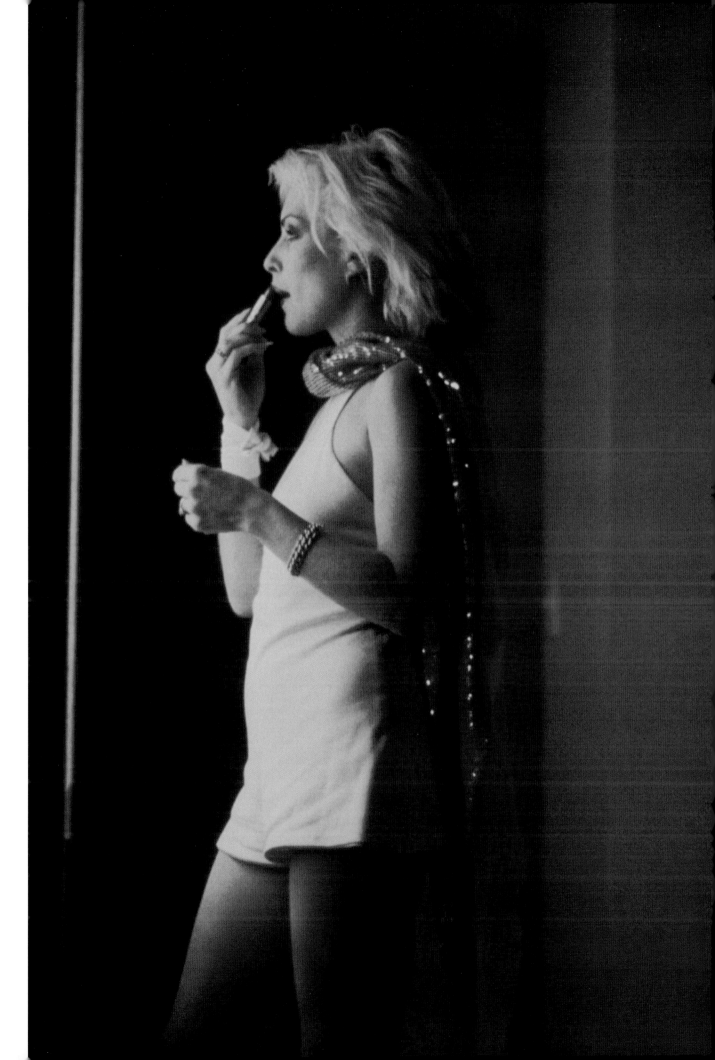

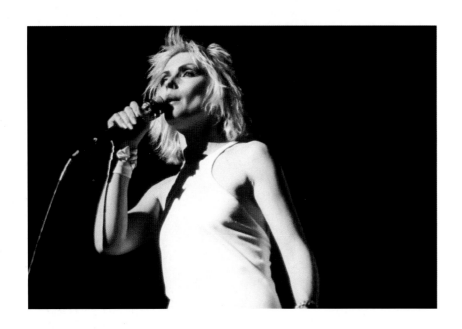

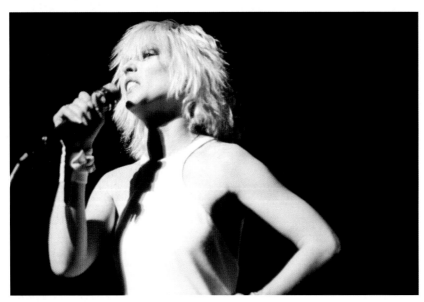

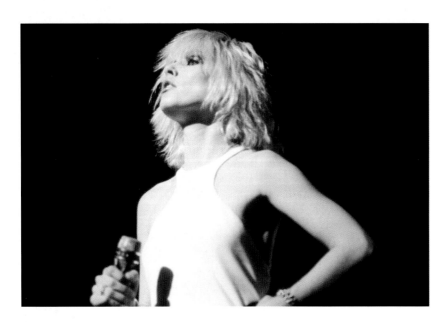

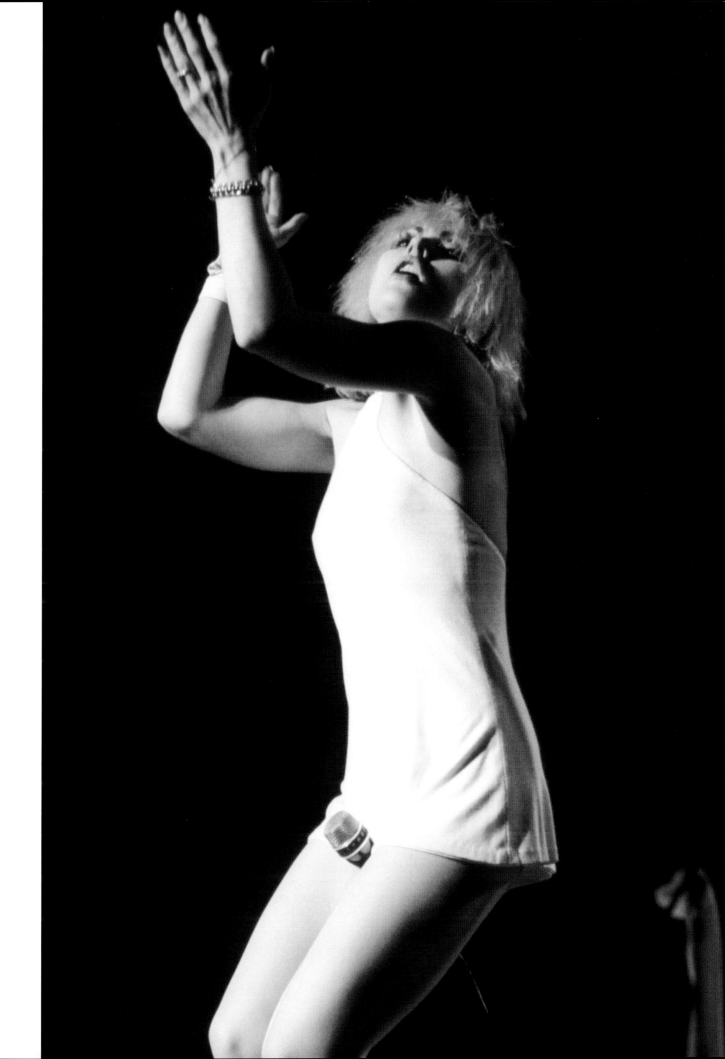

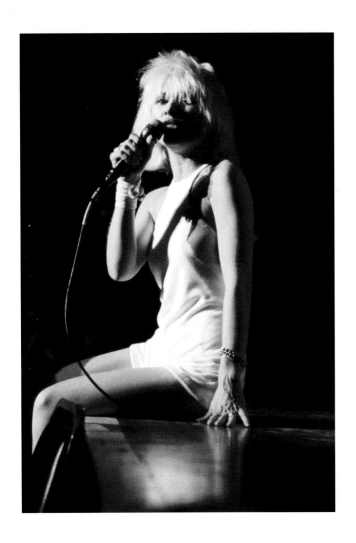

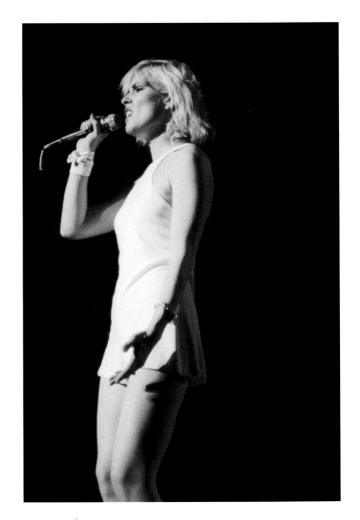

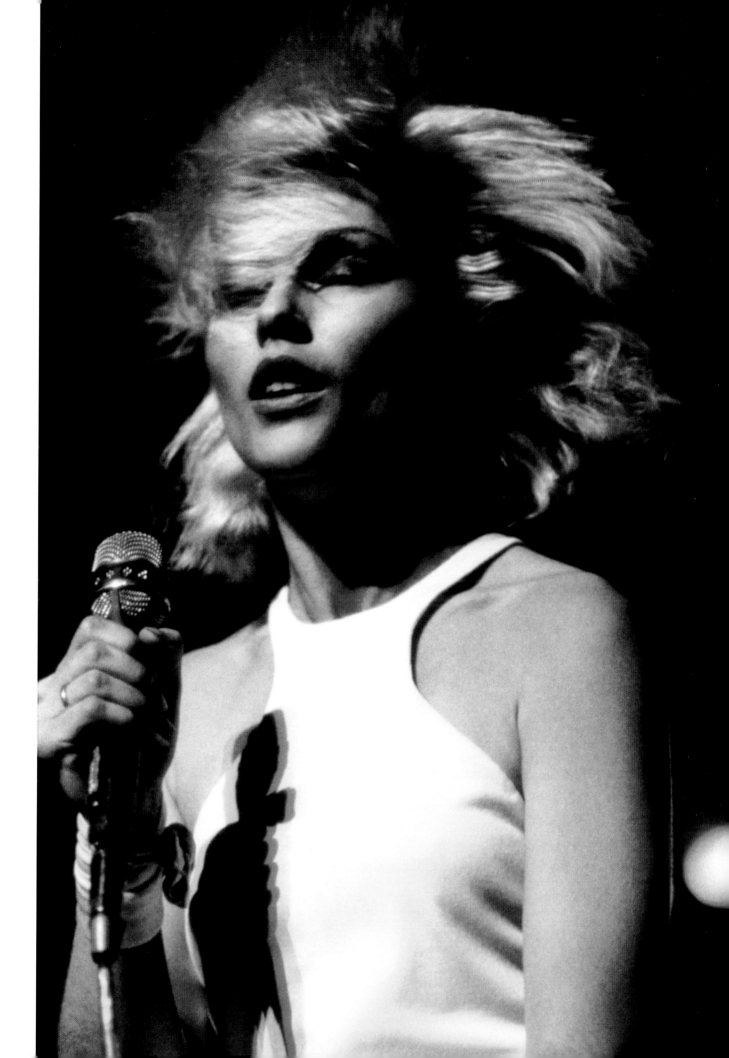

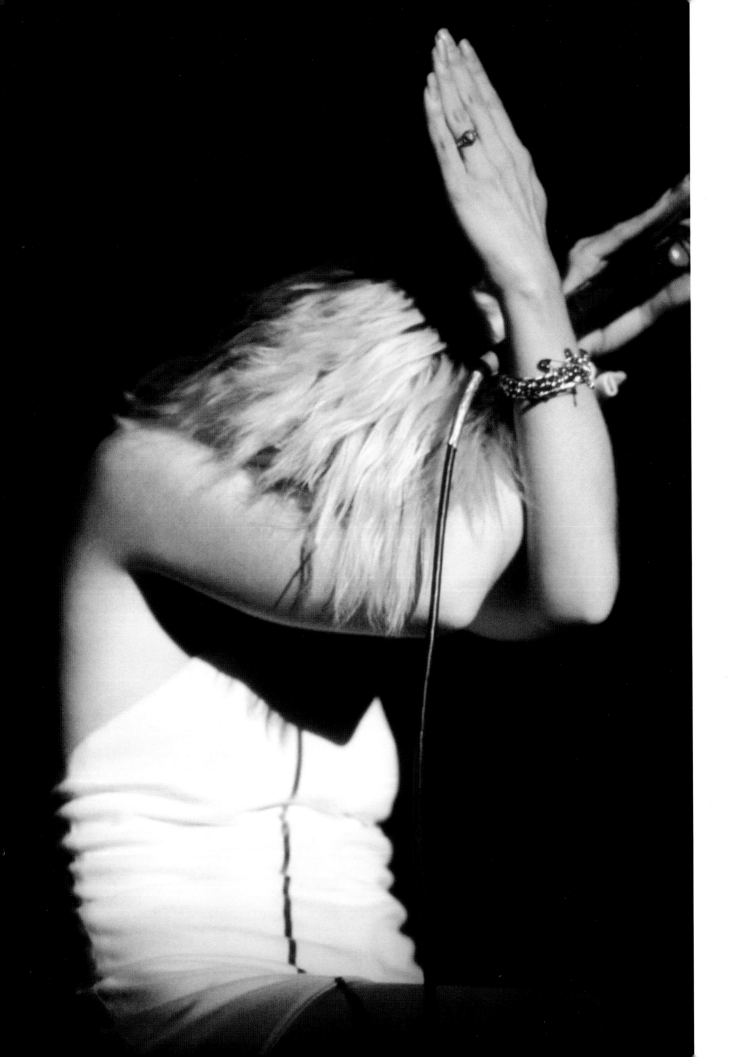

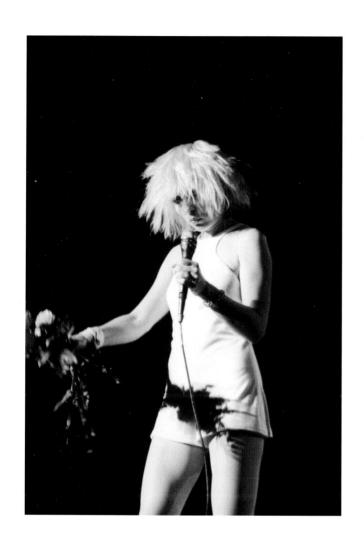

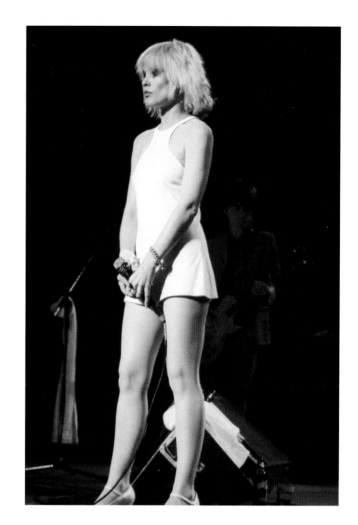

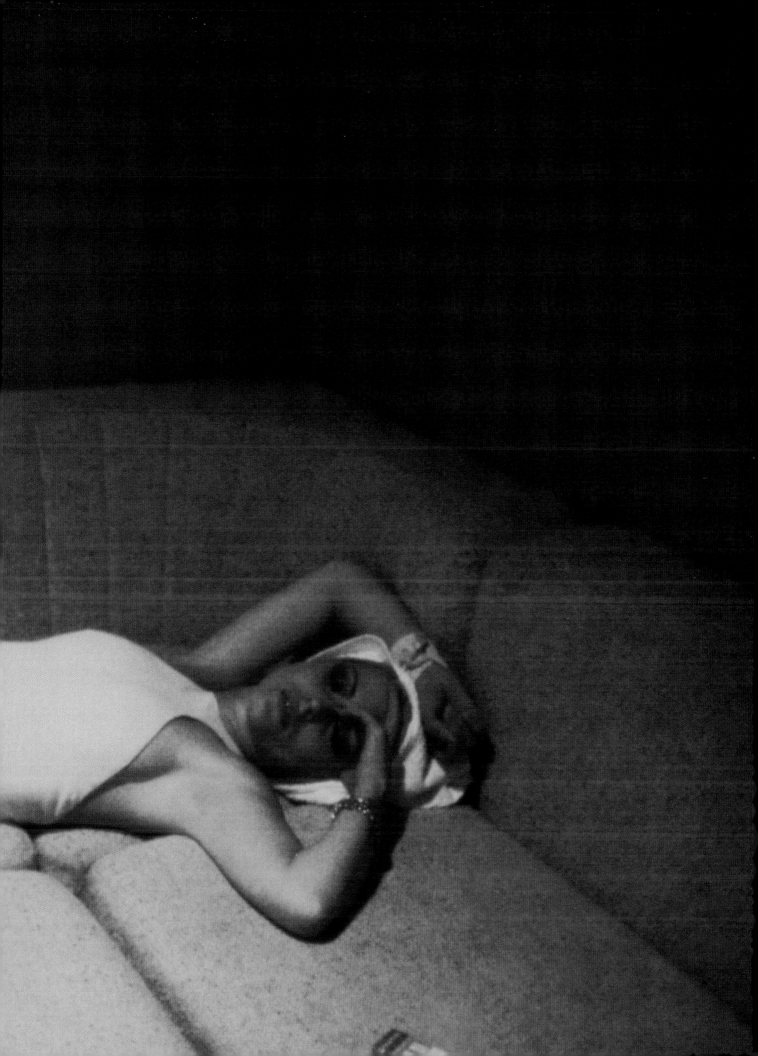

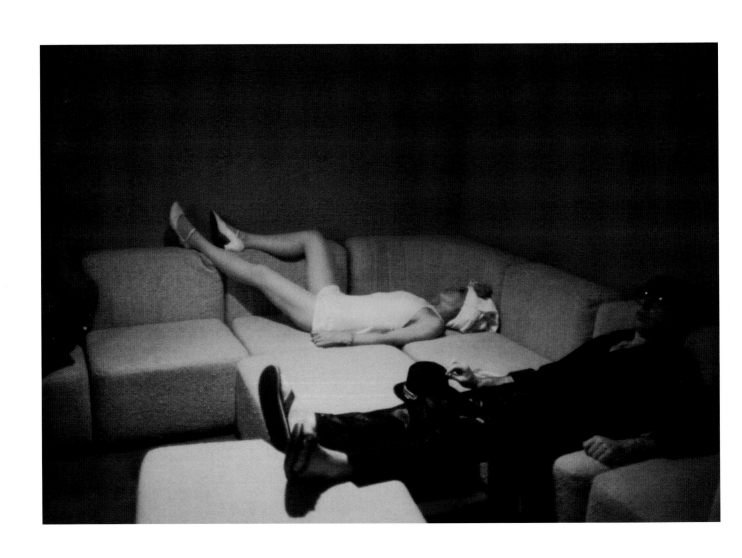

Previous pages and above:
Debbie and Chris relax after the show.
Right: Frankie Infante and his girlfriend.

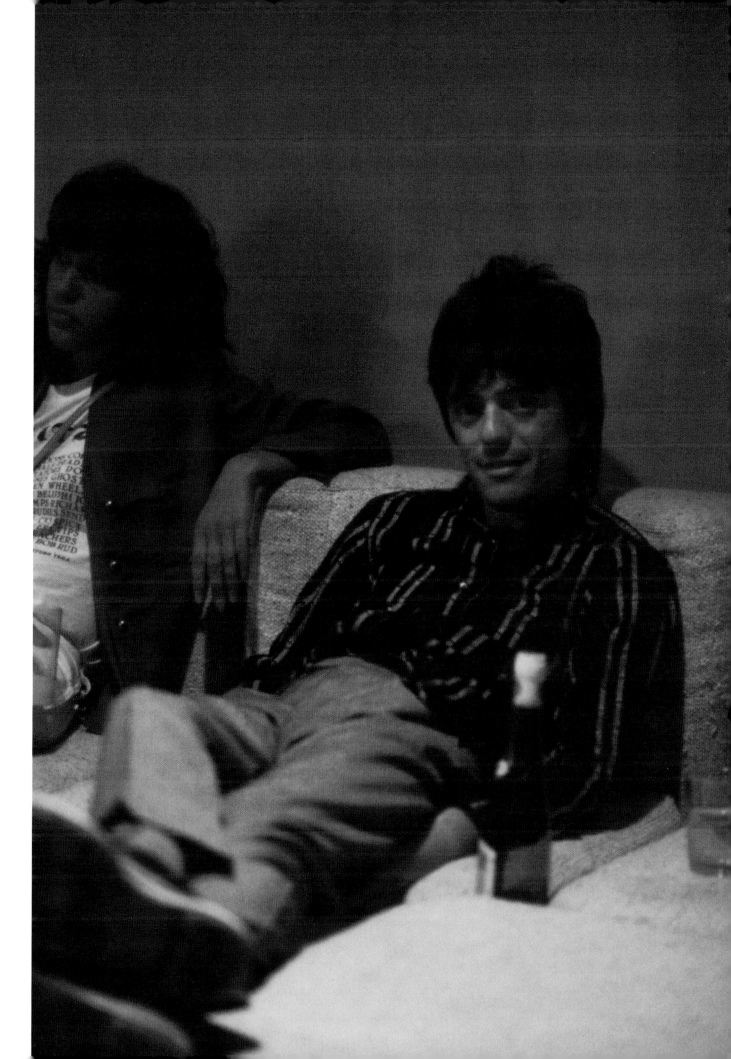

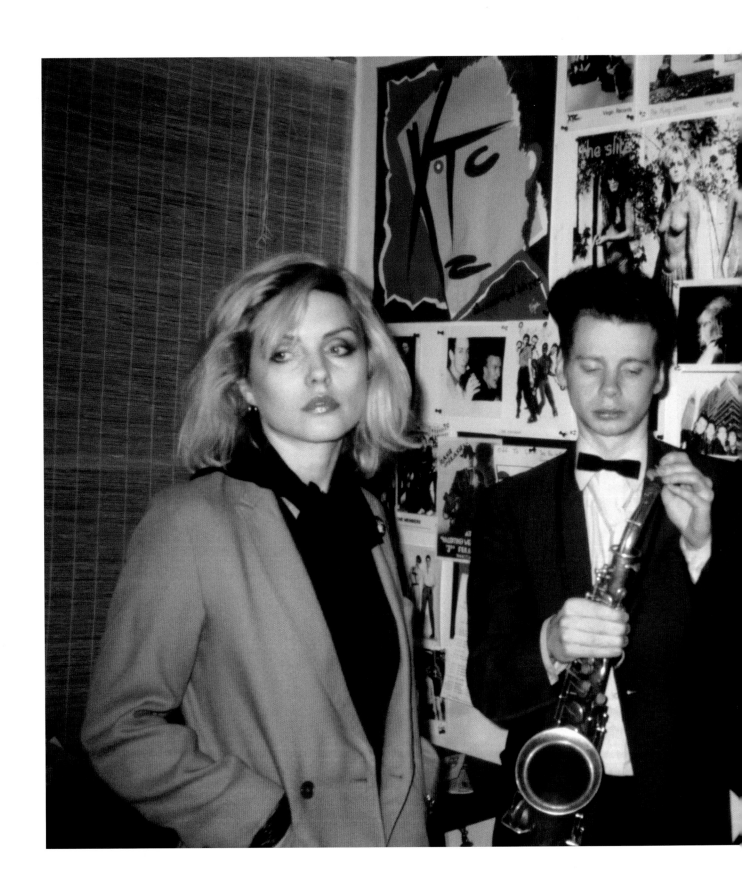

Above: *Debbie and Chris with their friend*
James White, A.K.A. James Chance.

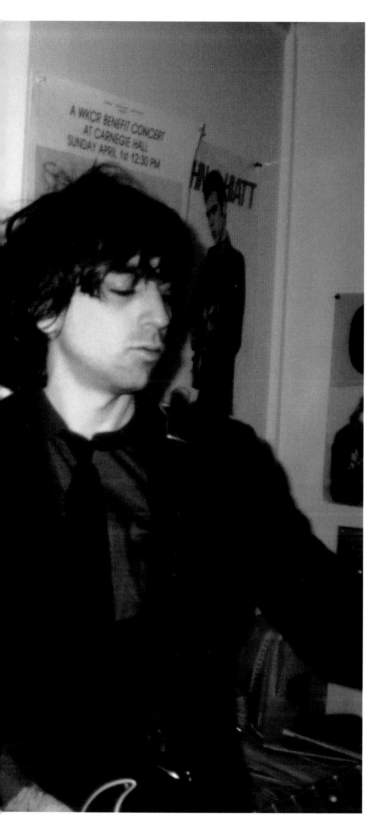

1980

Blondie continued to record and have hits with albums like *Eat To The Beat* and *Autoamerican*, until their break-up in the eighties. Then came their triumphant return in the nineties, which continues to this day. We have remained friendly throughout the years.

Whenever I see Clem, I get a big hug – he's such a great guy. Frank Infante lives in L.A., so I rarely see him, but I ran into Nigel Harrison only last week. He's semi-retired and lives between New York and Italy. I spoke to Jimmy Destri on the phone just yesterday, and he is always upbeat. Chris will be part of a photography show I am curating for exhibition in Japan. And of course Debbie has written the introduction to this book, and is always supportive and helpful. I count these people among my friends; we have all been through a lot, together and apart. We've shared experiences, lost mutual friends, and created memories that will always remain. Much of it is in Blondie's music, and I hope a little of it is in my photographs.

Roberta Bayley – New York, January 2006

ACKNOWLEDGEMENTS

I would like to dedicate this book to my three favourite blondes: Deborah Harry, Leee Black Childers and Cyrinda Foxe. Beneath the bleach beat hearts to be treasured.

Many thanks to Alexandra Tenenbaum, for all her support in helping me create this portrait of my years with Blondie. I am particularly grateful to Fabrice Couillerot, both for his friendship and support, but also for his skilful design of this book. Thanks to John Holmstrom for letting me use all the great *Punk* magazine artwork!

Thanks to all my friends, who have been so generous and supportive over the years. You know who you are; I couldn't have got through it without you. Thanks also to my family: my mother Helen and my brother Warner, and especially to Sidney and Preston, who bring me joy each day.

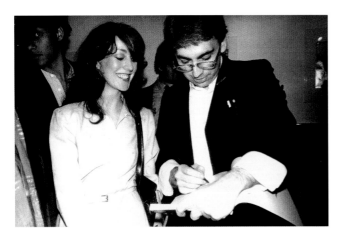

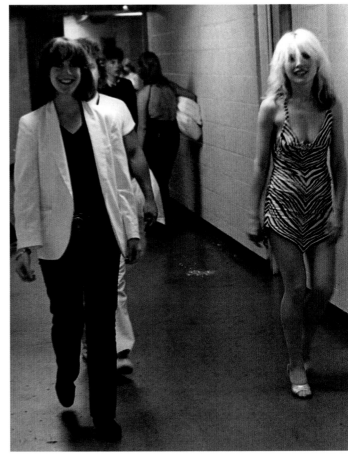

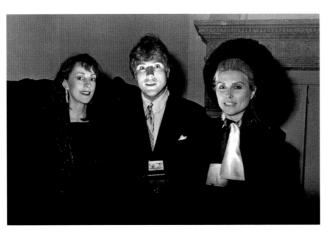

Published by Plexus Publishing Limited
25 Mallinson Road
London SW11 1BW
www.plexusbooks.com
First printing 2007

British Library Cataloguing in Publication details

Bayley, Roberta
Blondie : unseen, 1976-1980
1. Harry, Debbie - Pictorial works 2. Blondie
(Musical group) - Pictorial works
I. Title
782.4'2166'0922

ISBN-10: 0-85965-396-X
ISBN-13: 978-0-85965-396-1

Cover and Book designed by Fabrice Couillerot

Photographs:
page 2/3 copyright Bobby Grossman;
page 95 (below) copyright David Gahr;
page 136 (right) copyright Bob Gruen.

Published by arrangement with Vade Retro, Paris

Top left: *Roberta Bayley and Chris Stein.*
Lower left: *The photographer with Glenn O'Brien
(producer of the TV show* Beat Party*) and Debbie Harry.*
Right: *Roberta and Debbie by Bob Gruen.*